A View Through My Lens

Brandy Lindsey

Copyright © 2012 Brandy Lindsey

All rights reserved.

ISBN: 1477463453
ISBN-13: 978-1477463451

DEDICATION

For Paul, who despite the distance between us remains just as close.

CONTENTS

Acknowledgments	i
Downtown Nashville	1-11
Shadow Trees	12-13
Fencerow	14
Flower	15
Clouds	16-17
Trees	18-23
Barns	24-27
Barren River Lake	28-35
Peaceful Decay	36-41
Sky at Sunset	42-43
Author's Note	44

ACKNOWLEDGMENTS

Many thanks to Mom for being right once again, to Dad for introducing me to Nikon, to Madeline and Robert for having patience every time you both had to wait for me to get that perfect shot, and to God for leading me to where I am today.

Let each man exercise the art he knows.
		Aristophanes

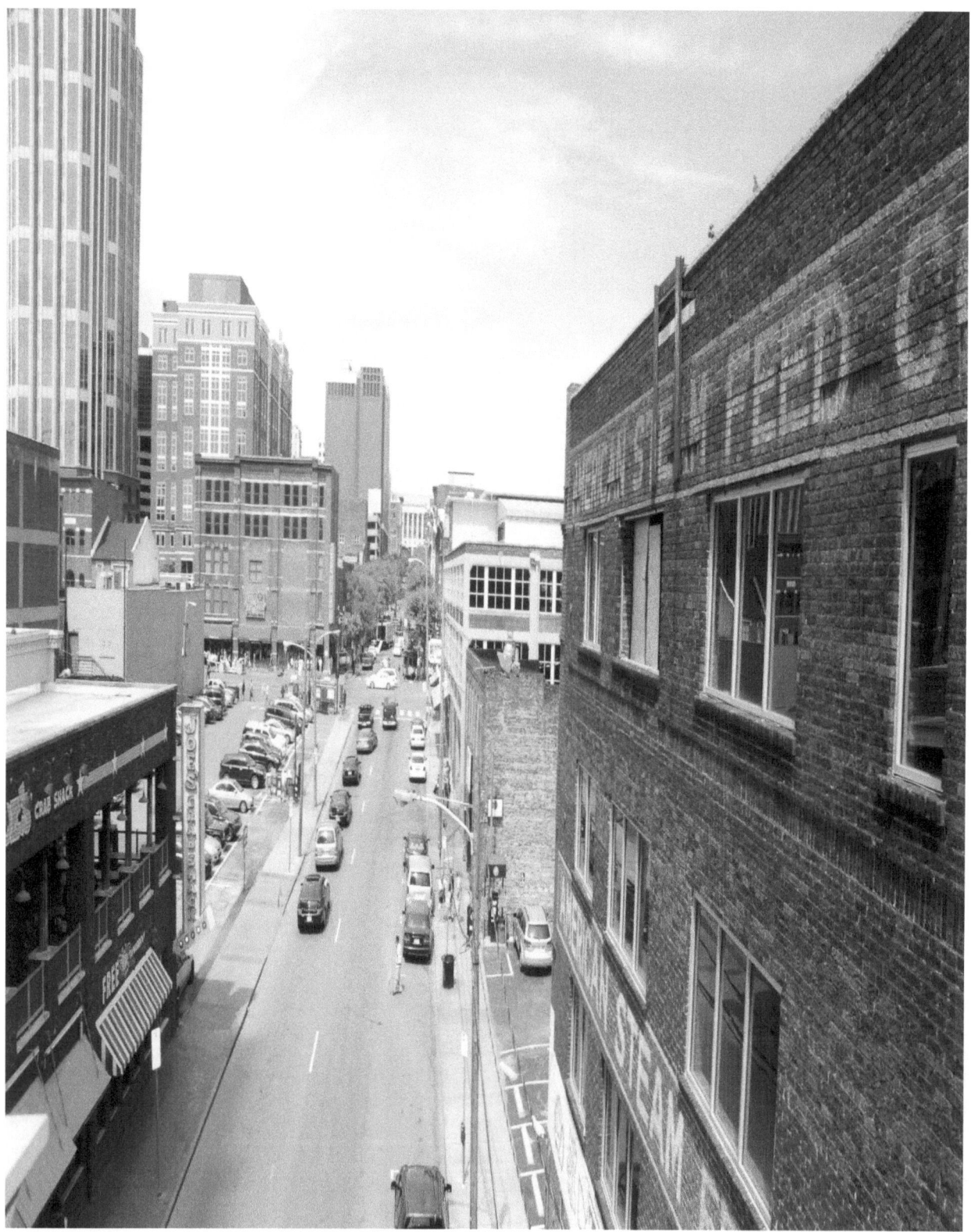

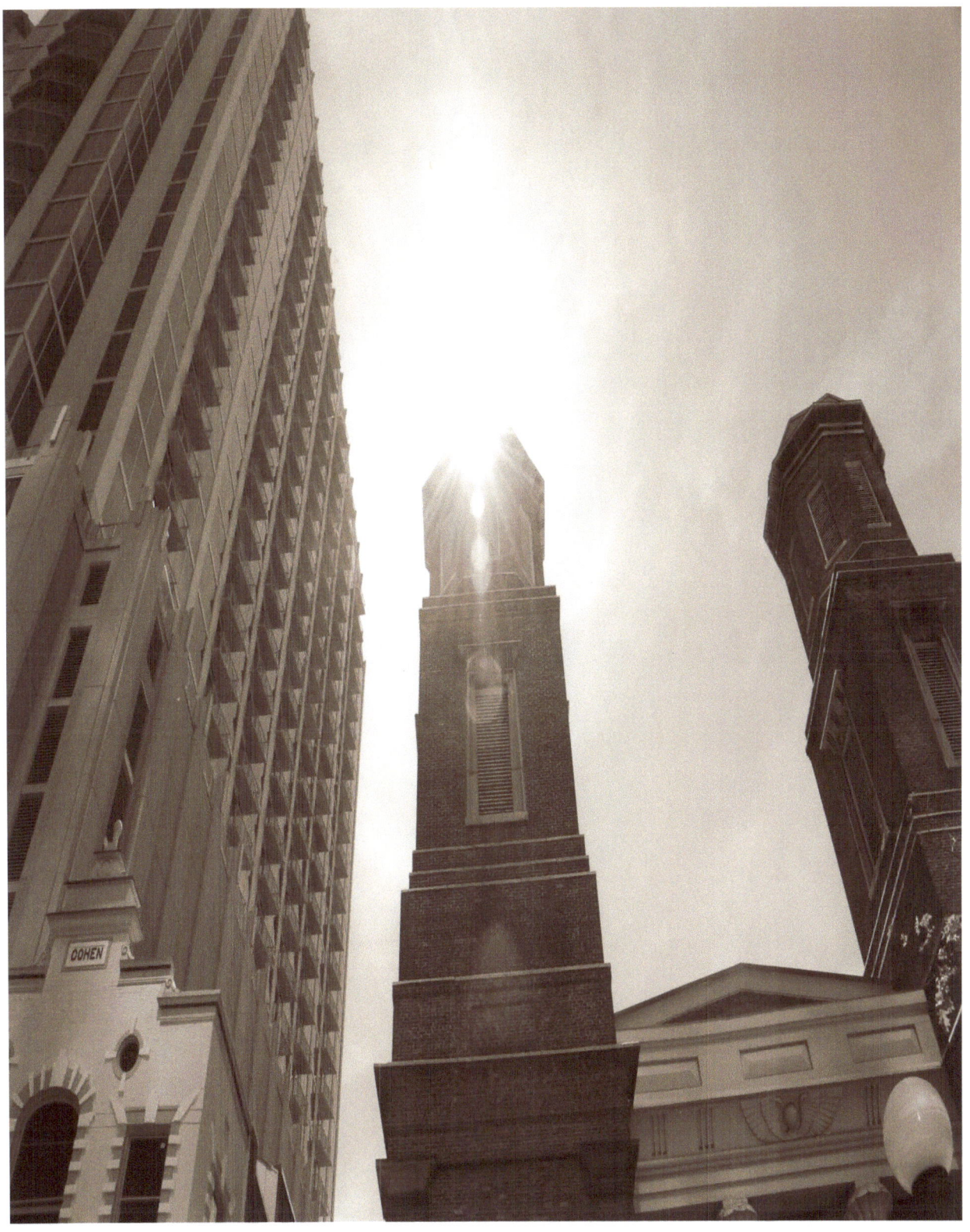

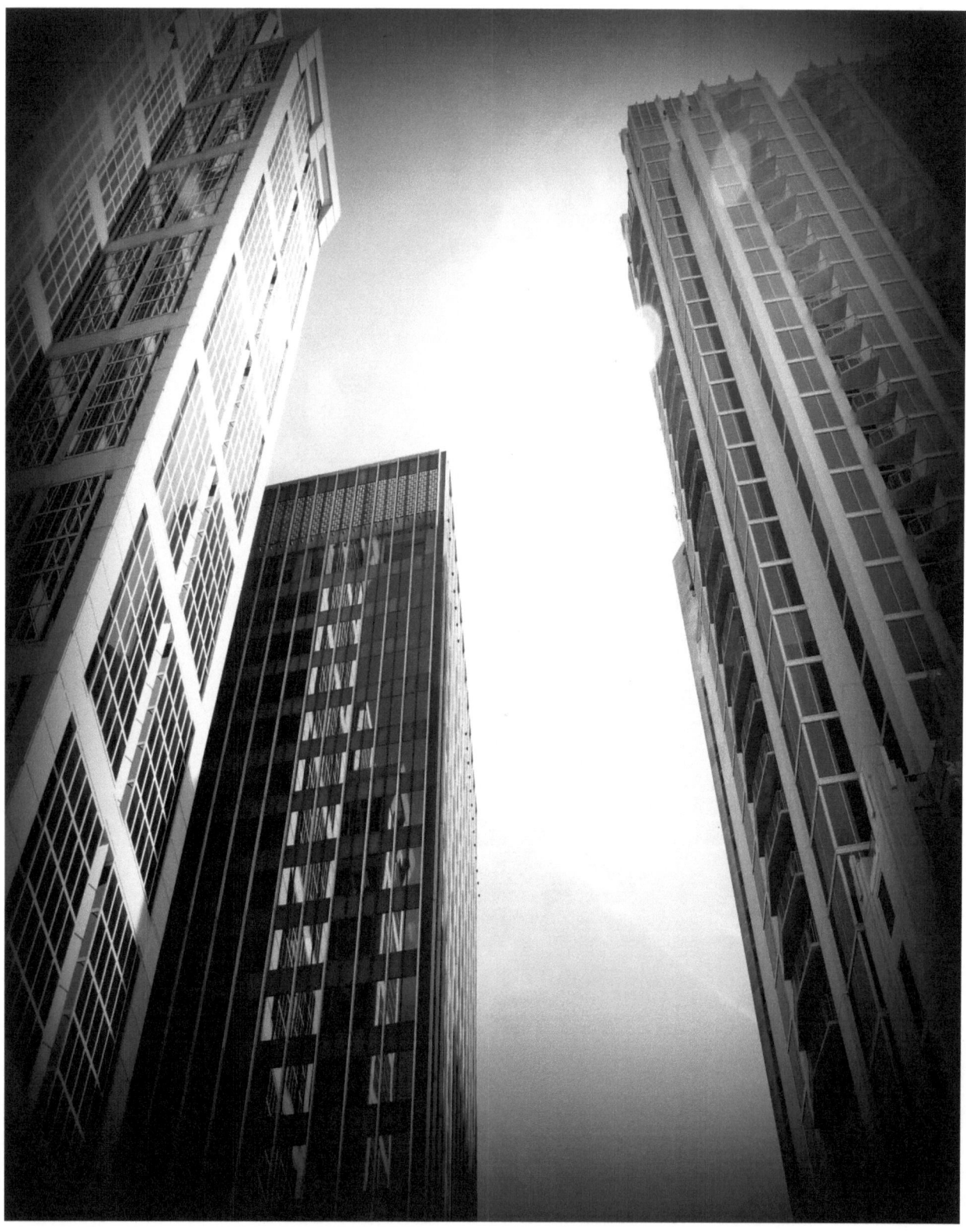

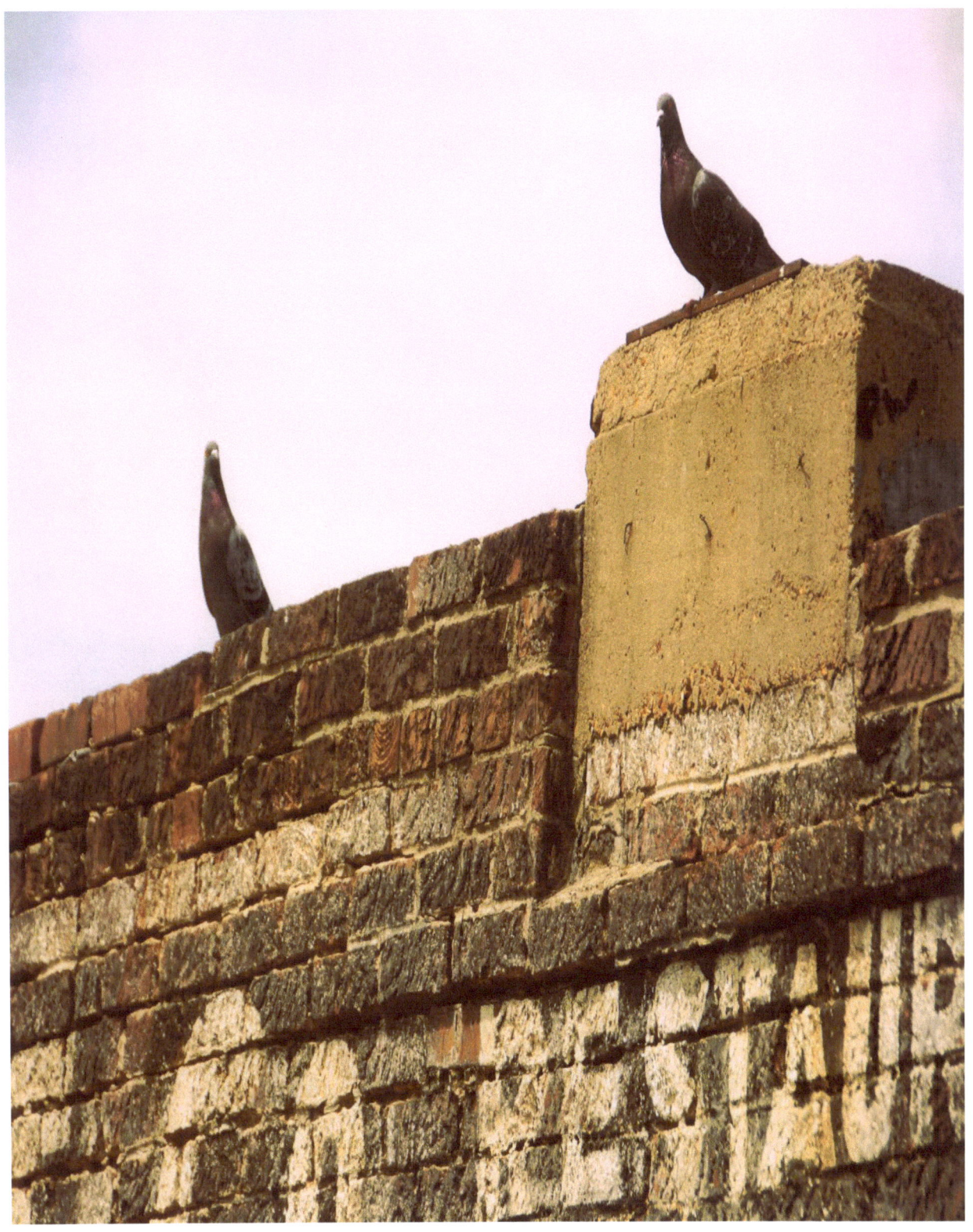

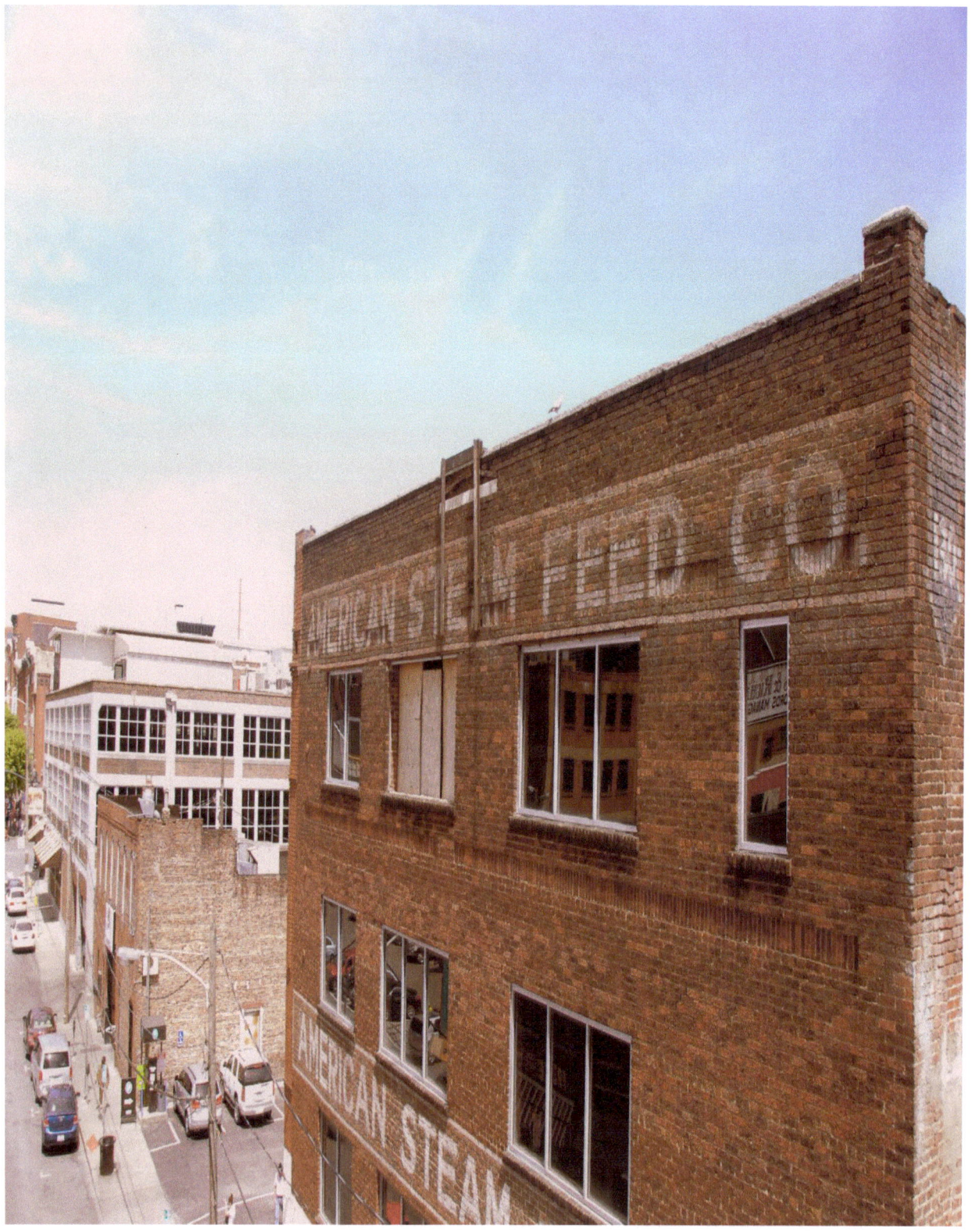

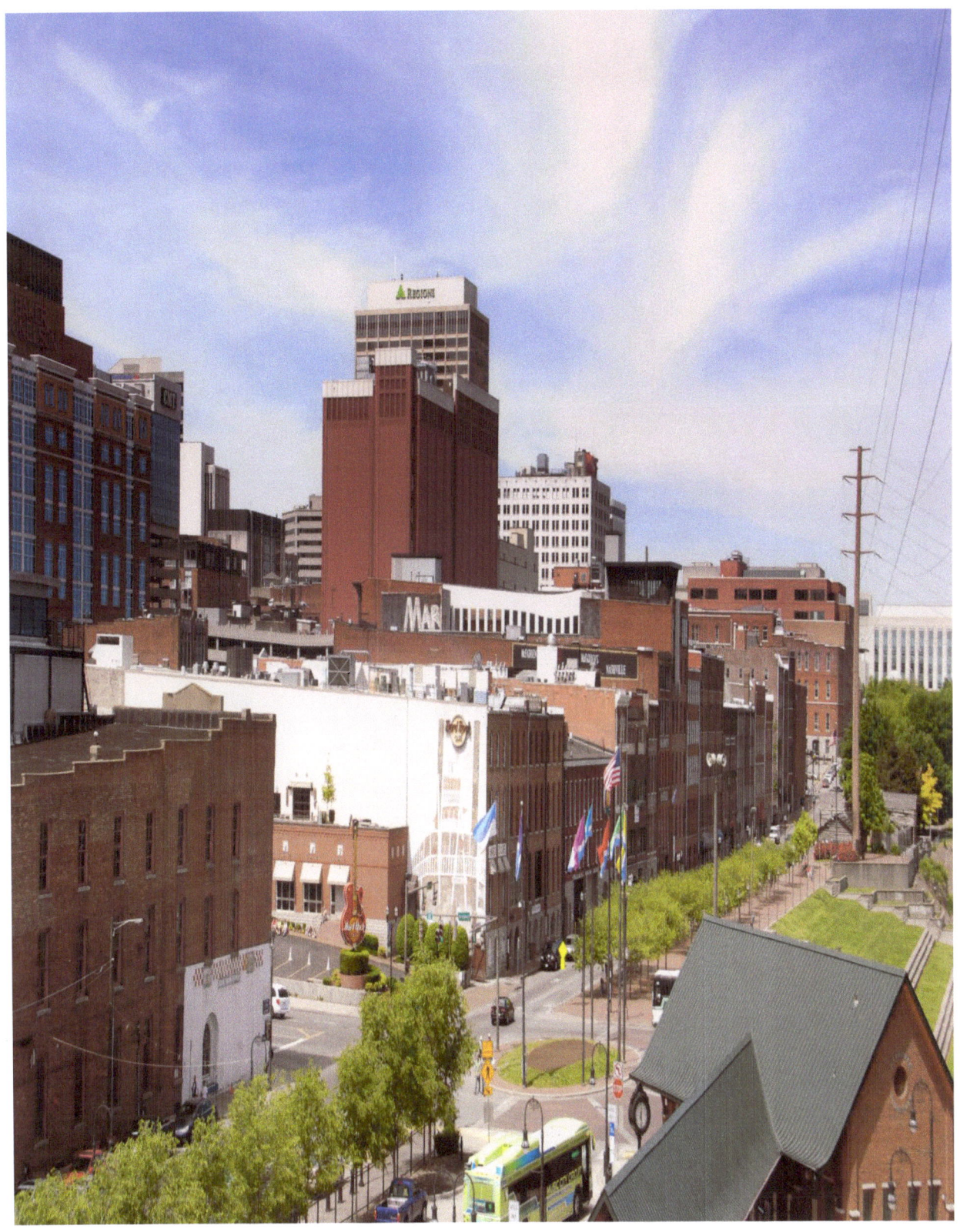

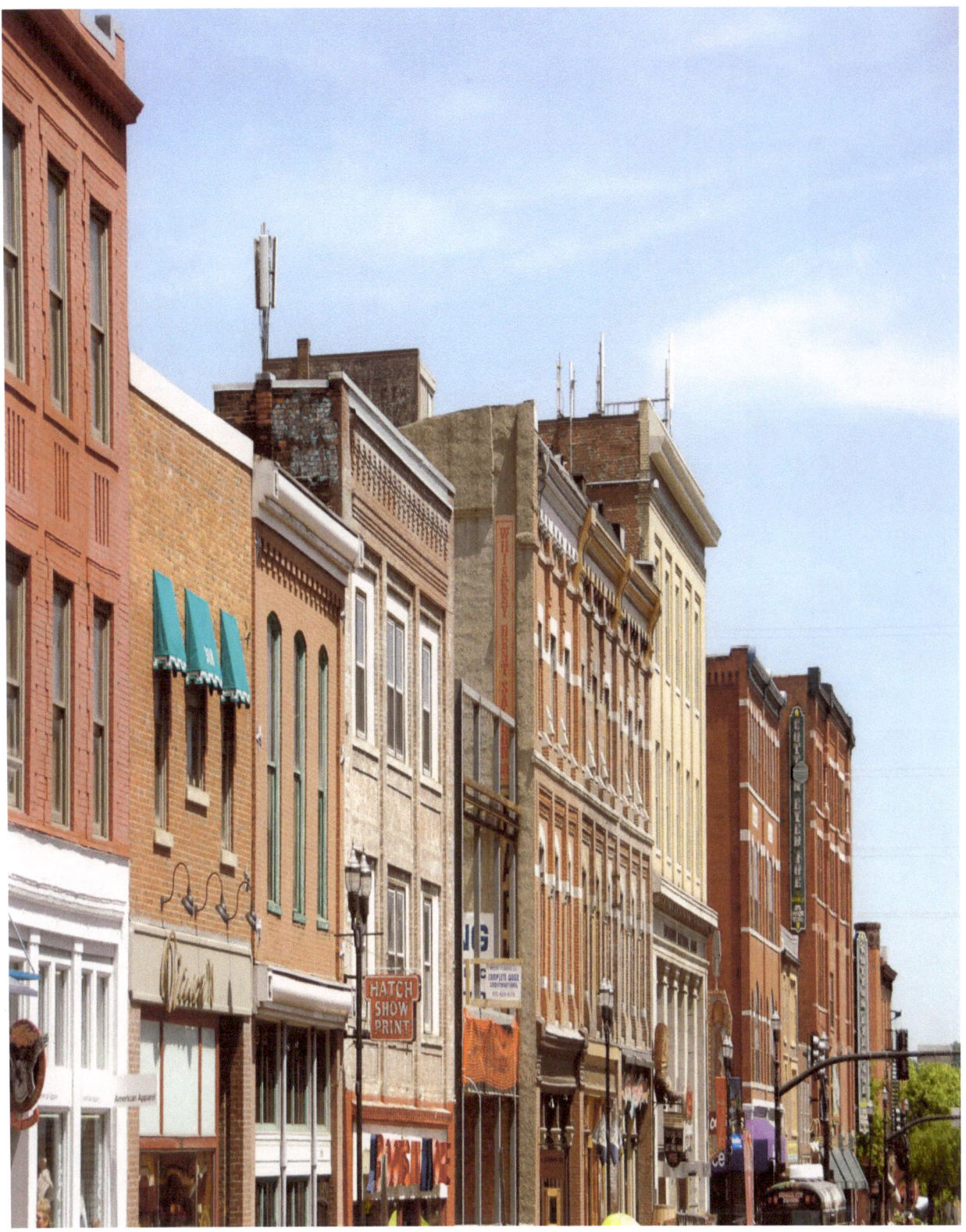

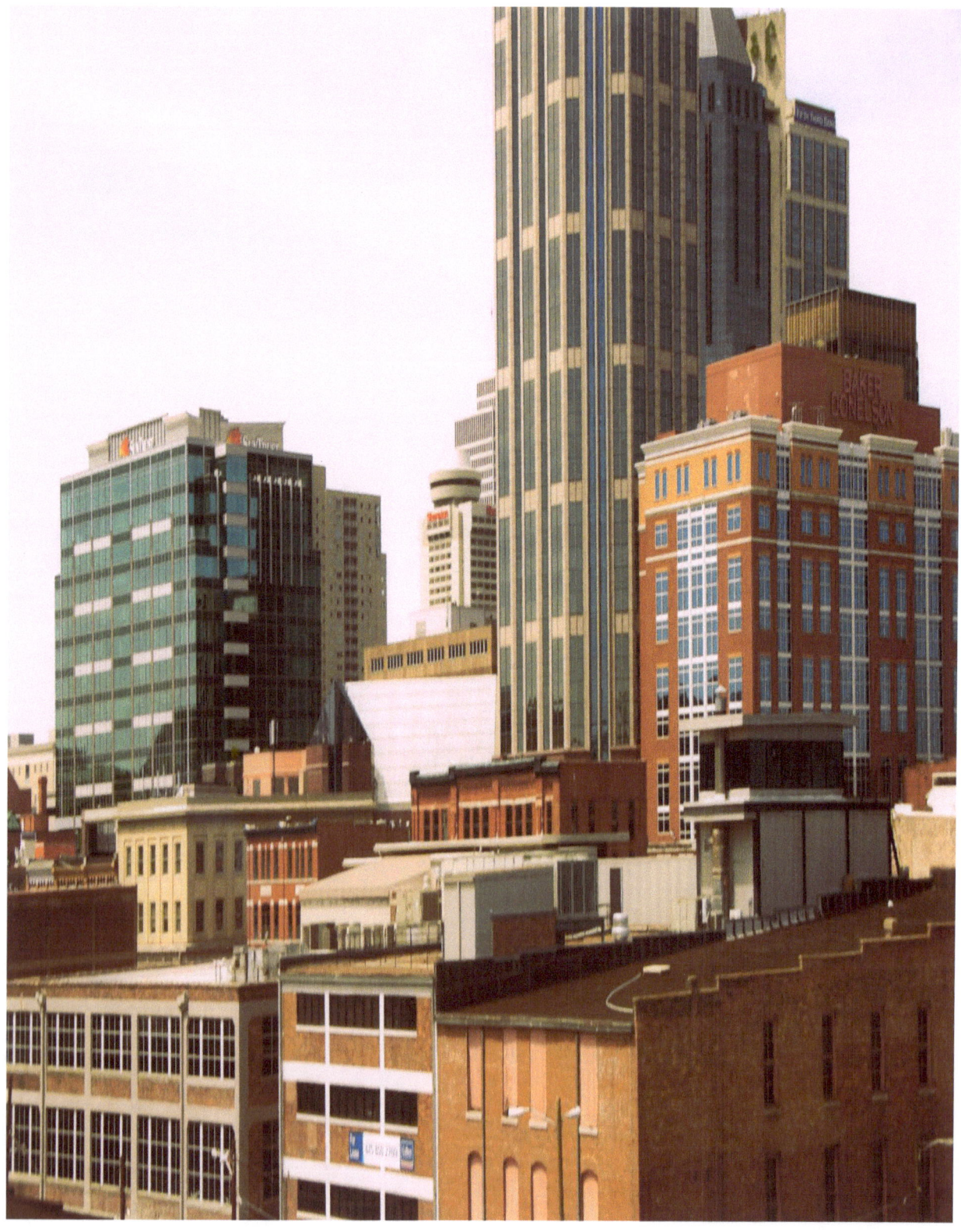

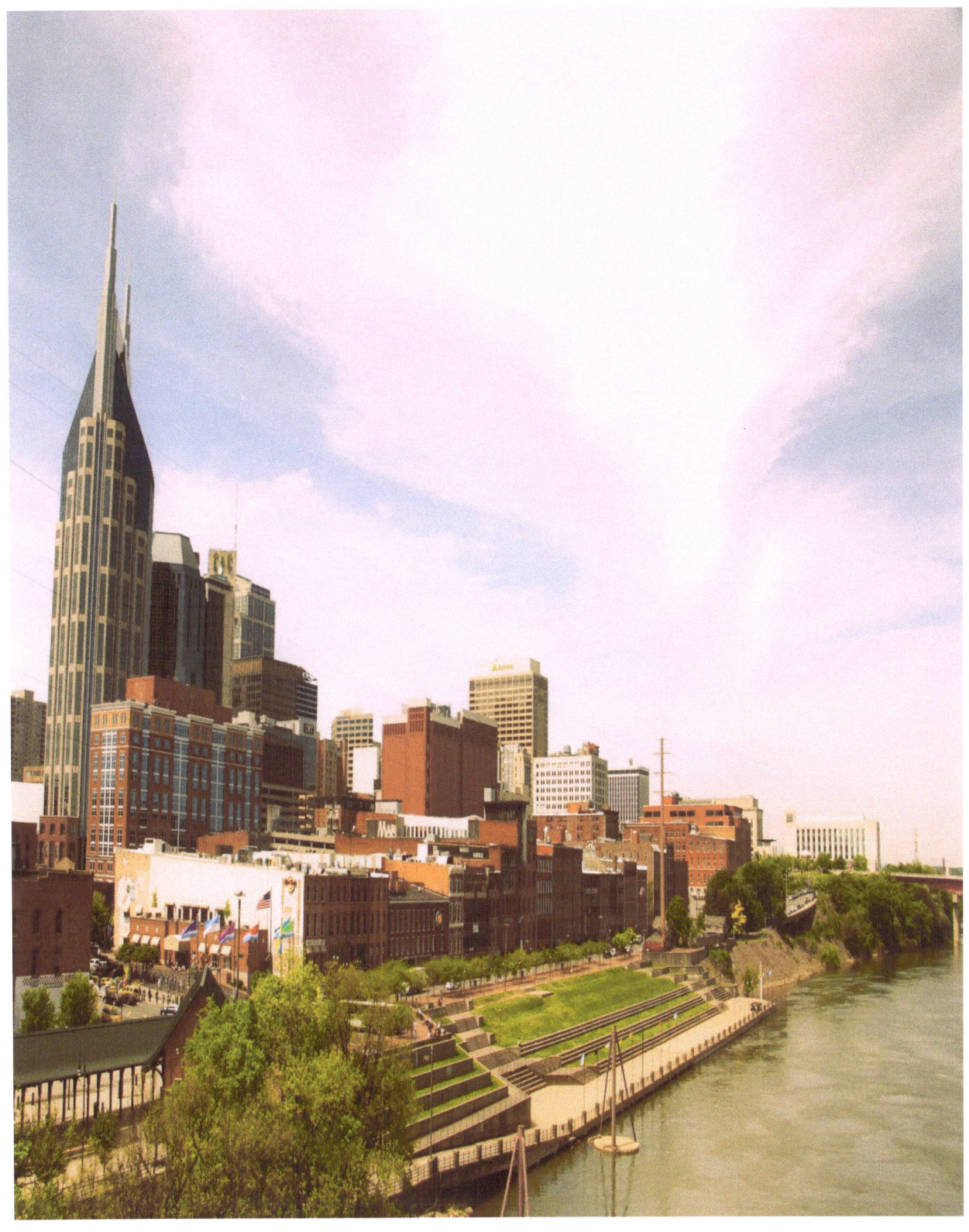

Far away in the sunshine are my highest aspirations.
I may not reach them, but I can look up and see their beauty,
believe in them, and try to follow where they lead.
Louisa May Alcott

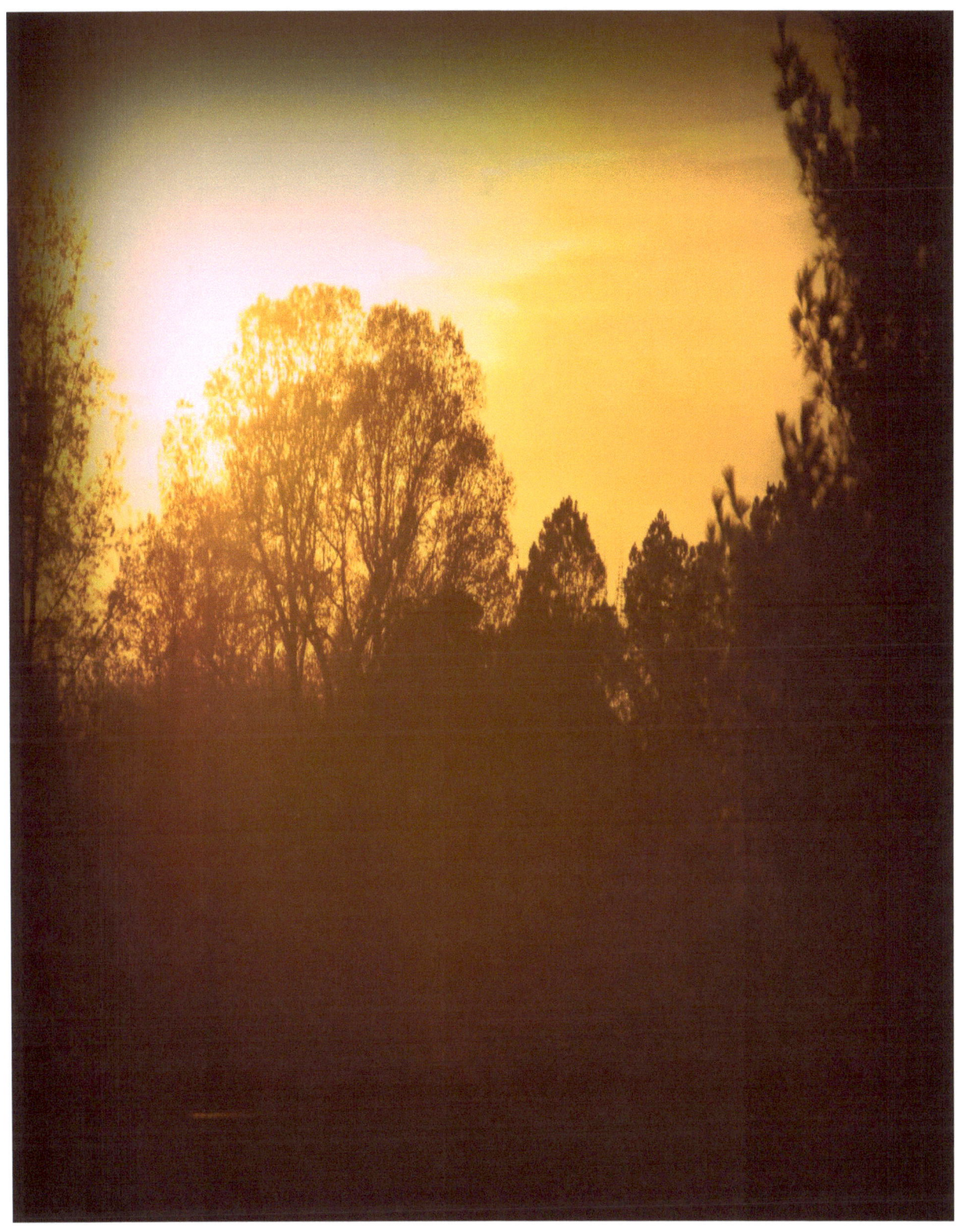

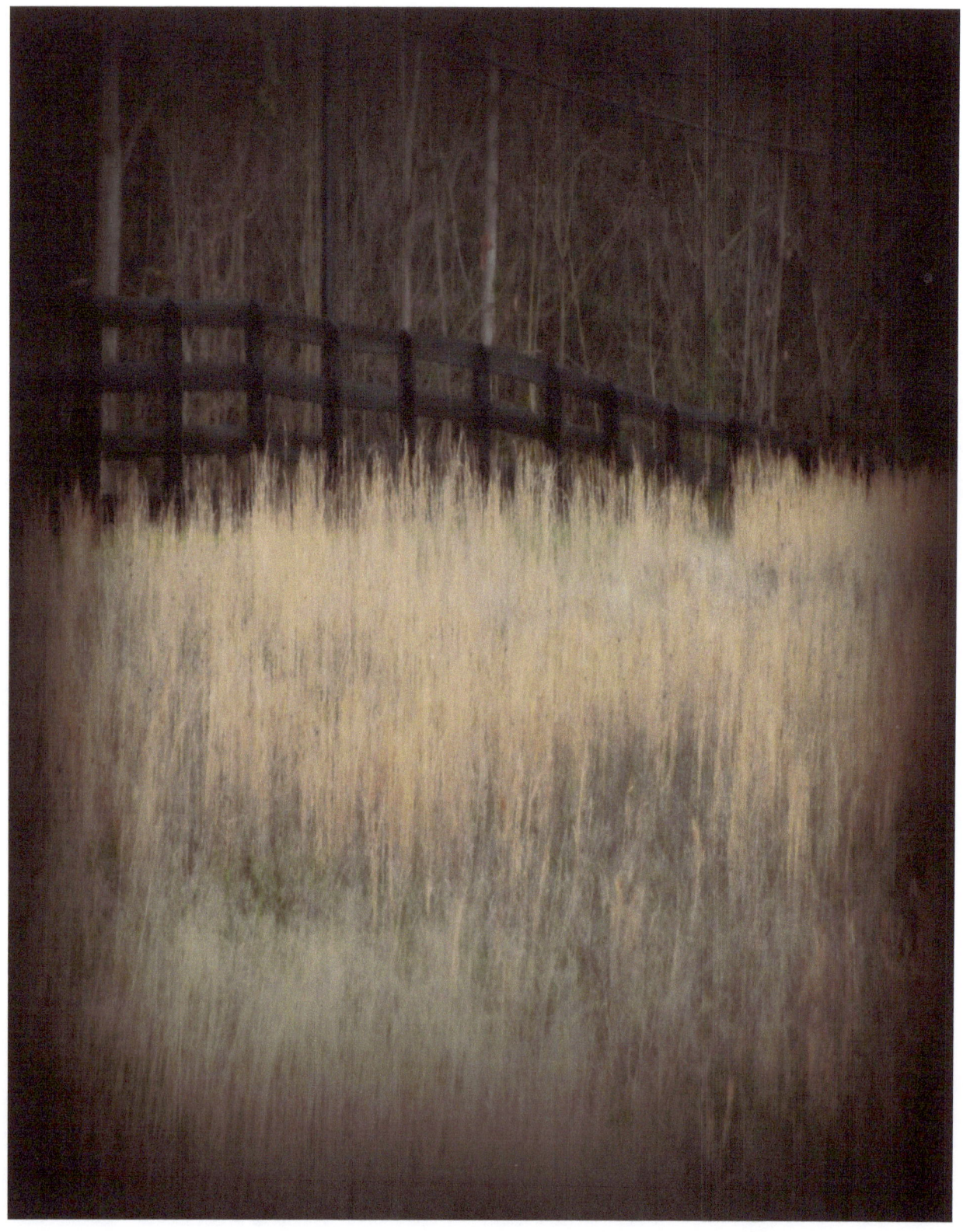

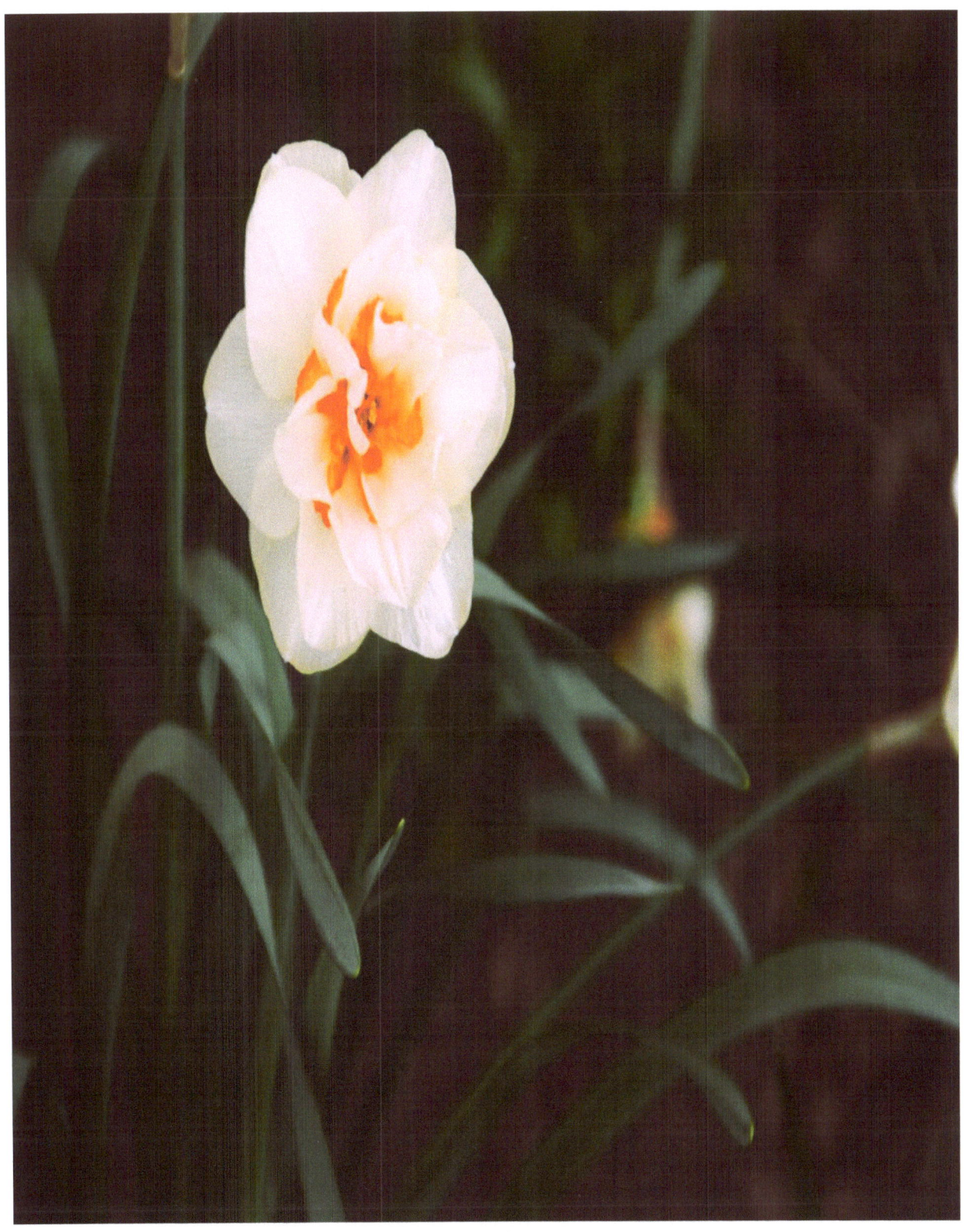

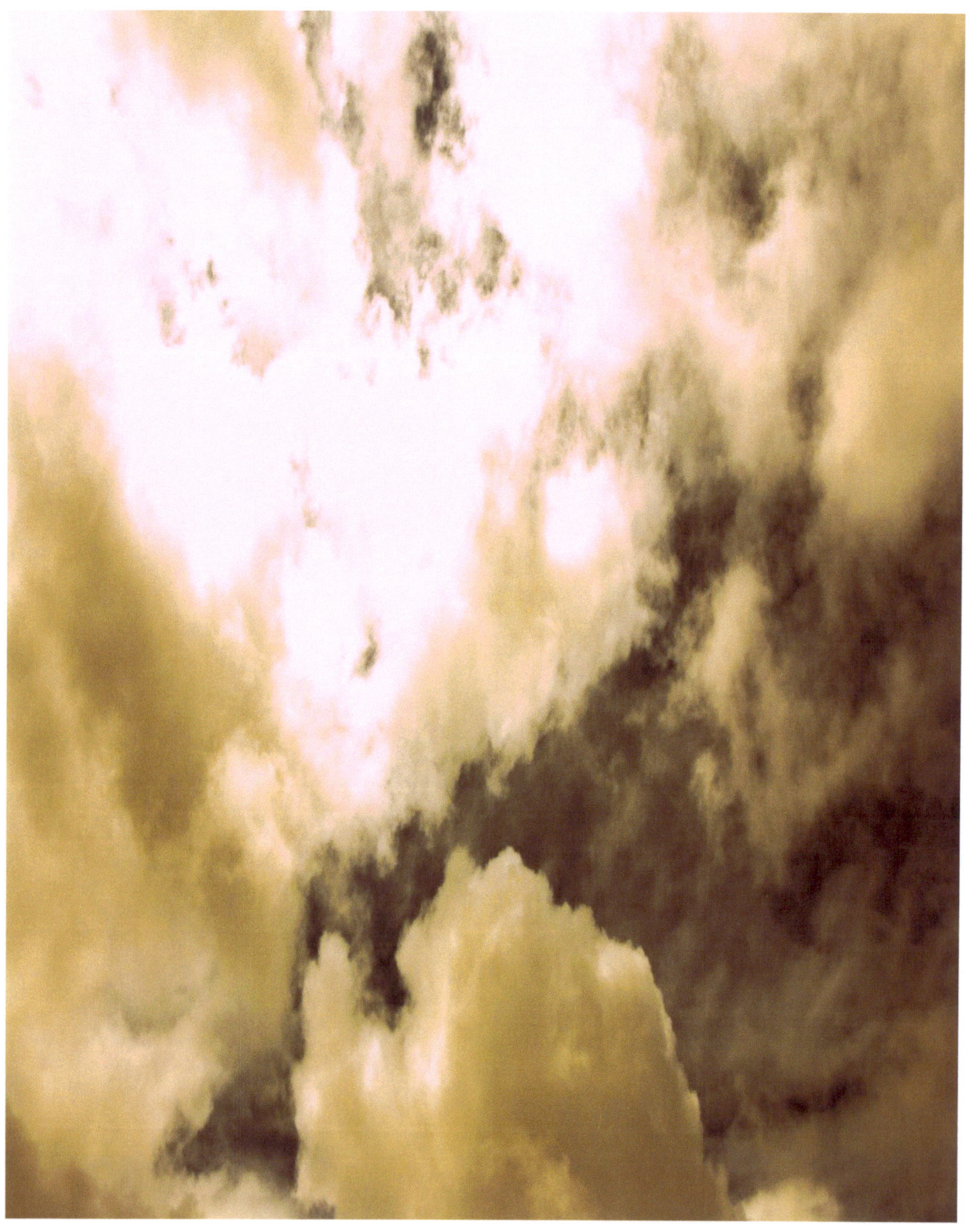

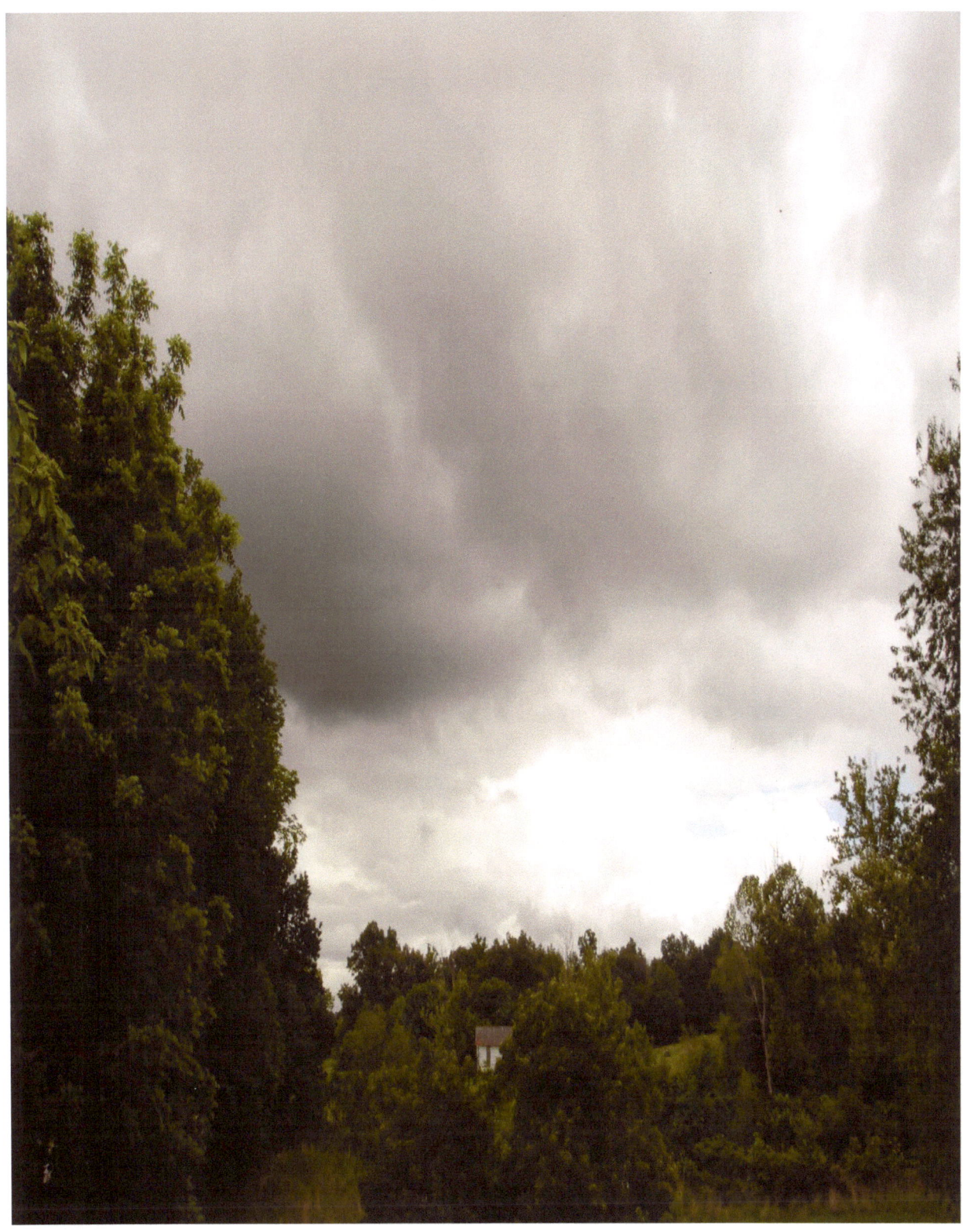

All things are artificial, for nature is the art of God.
Thomas Browne

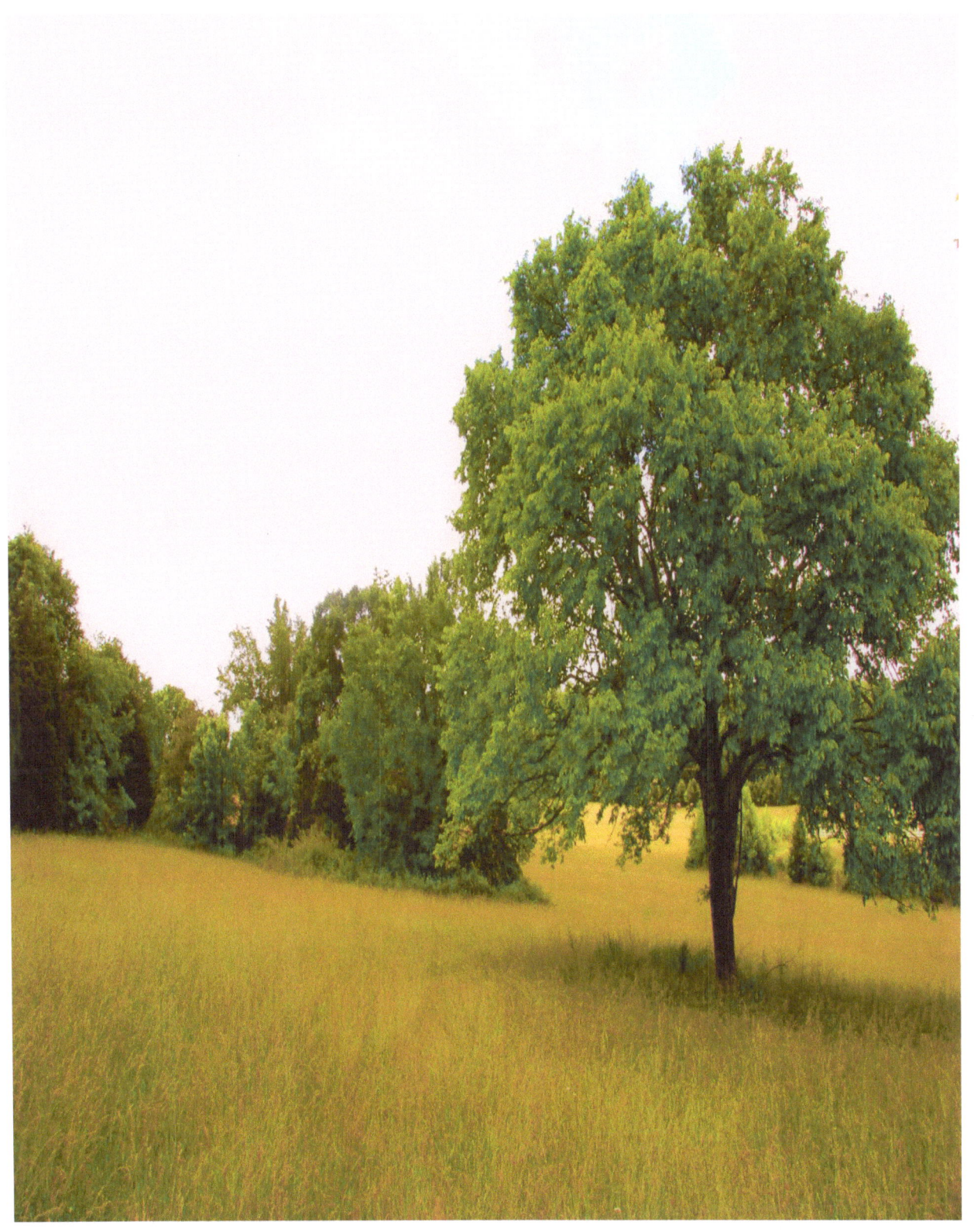

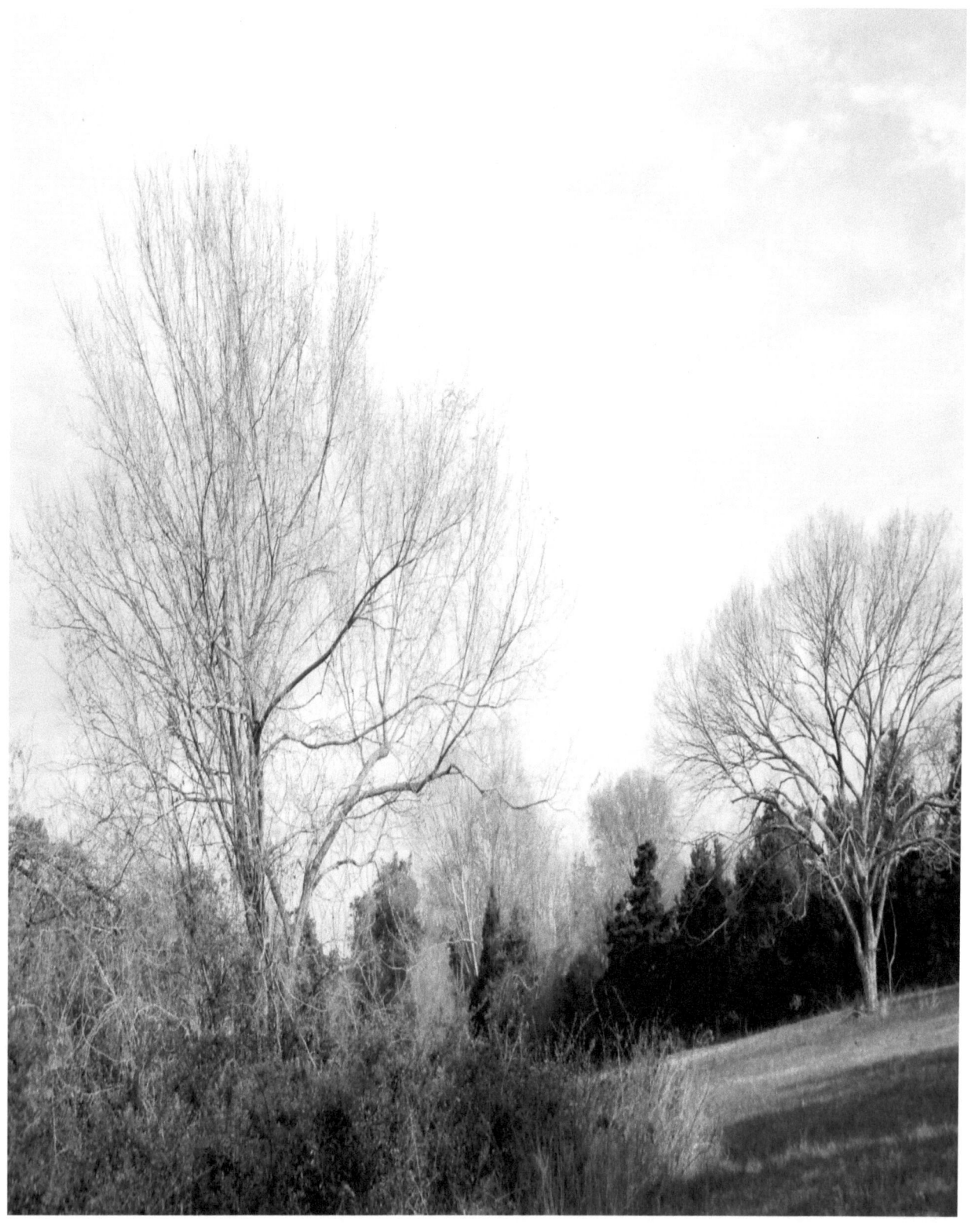

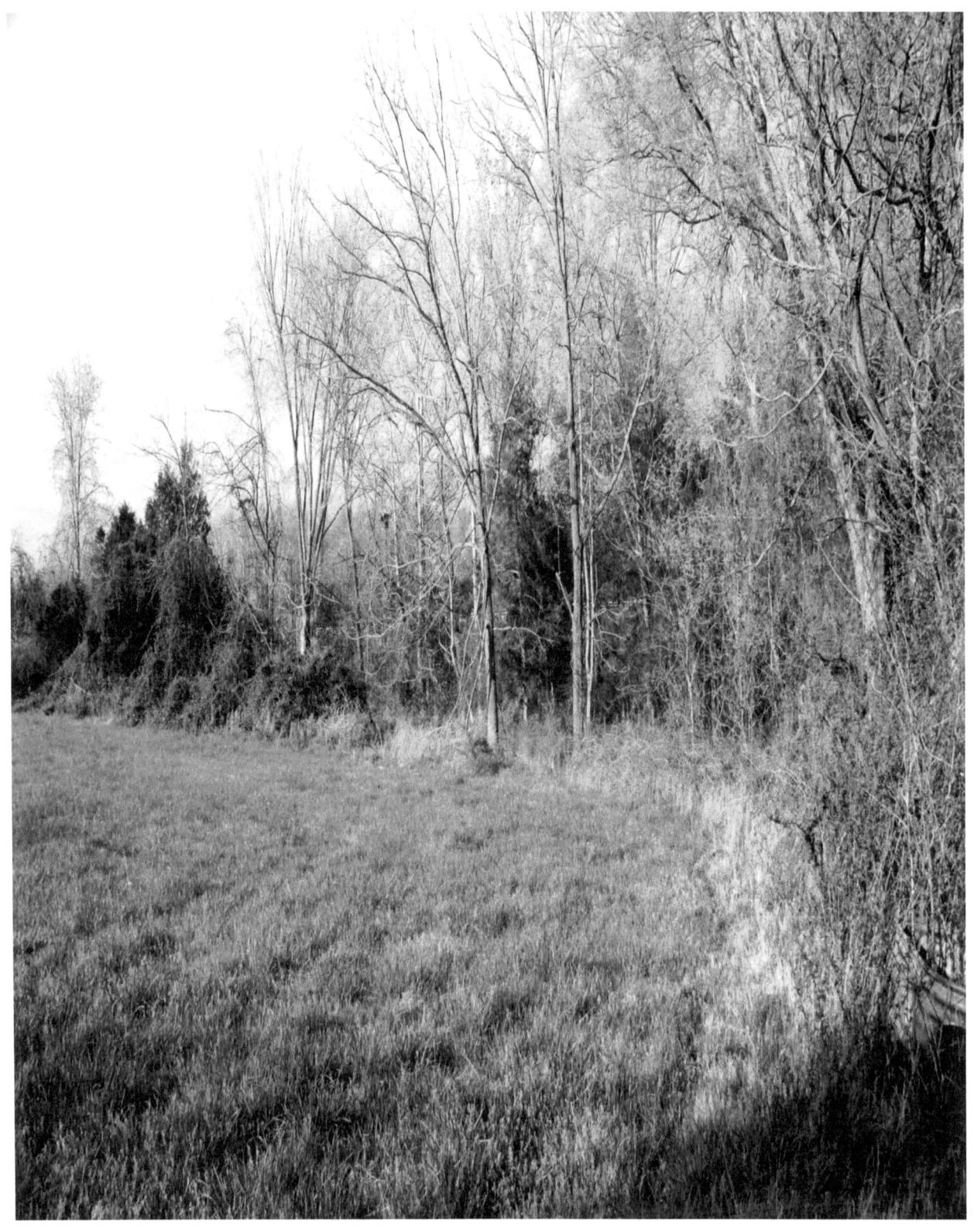

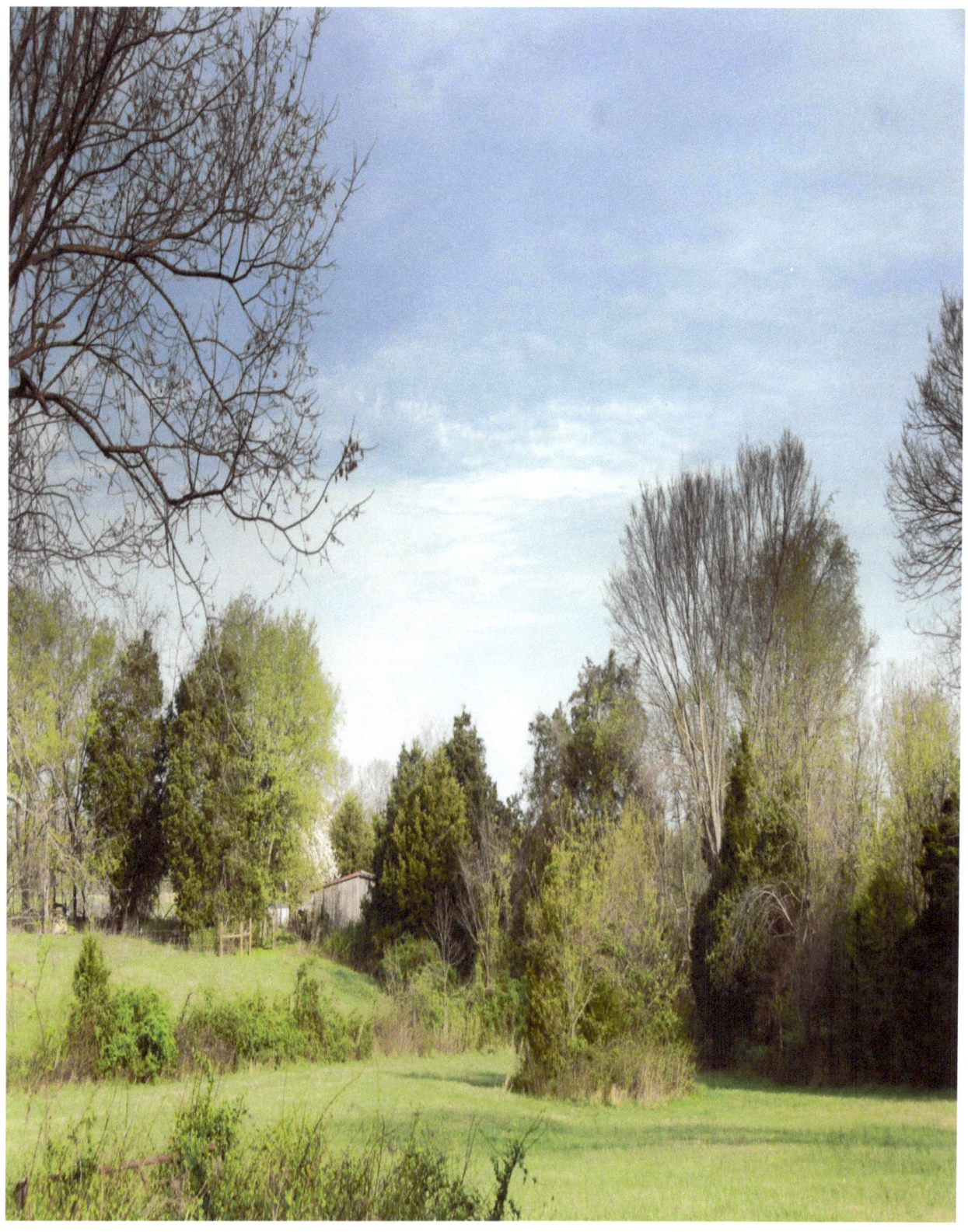

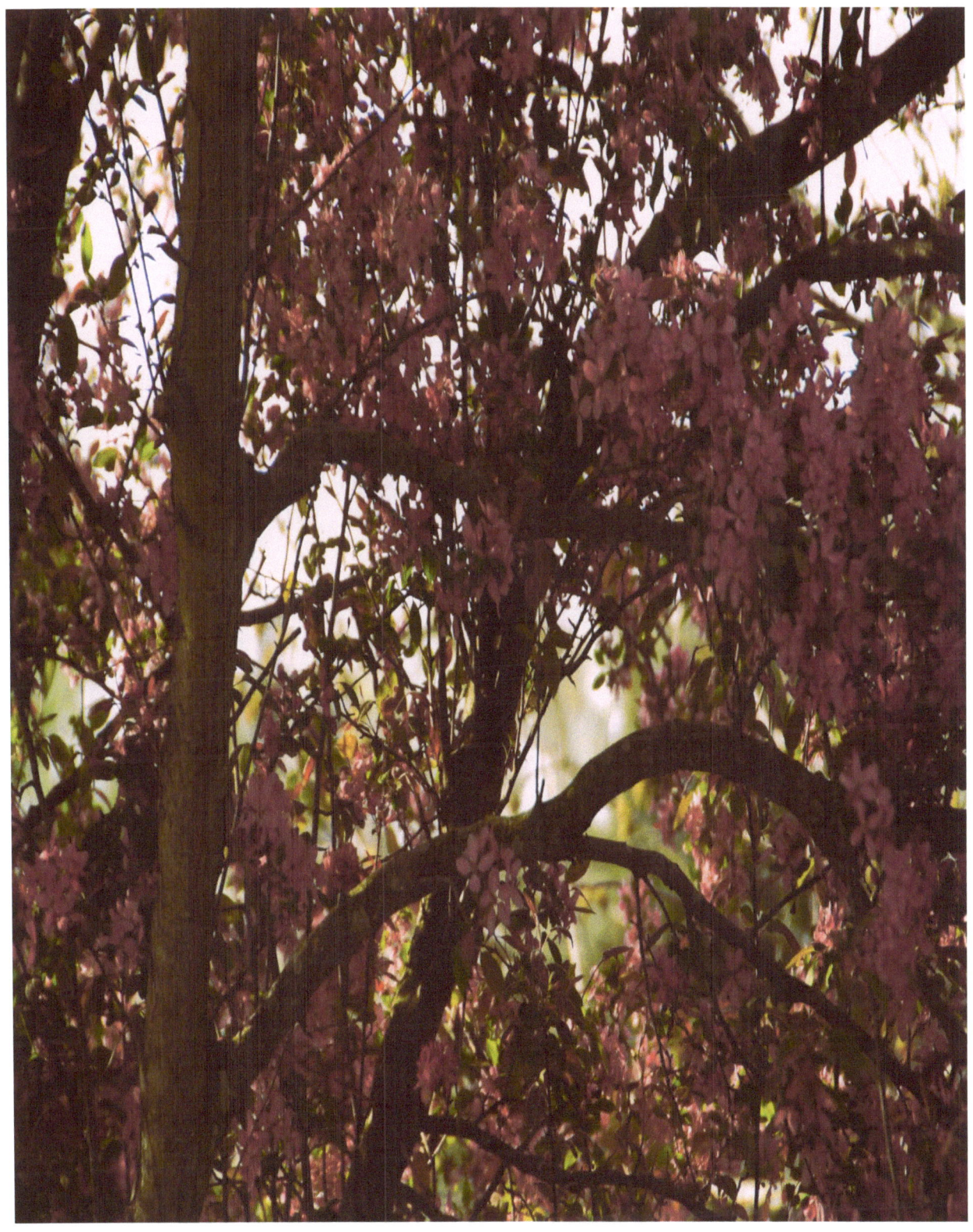

A dreamer is one who can only find his way by moonlight,
and his punishment is that he sees the dawn before the rest of the world.
Oscar Wilde

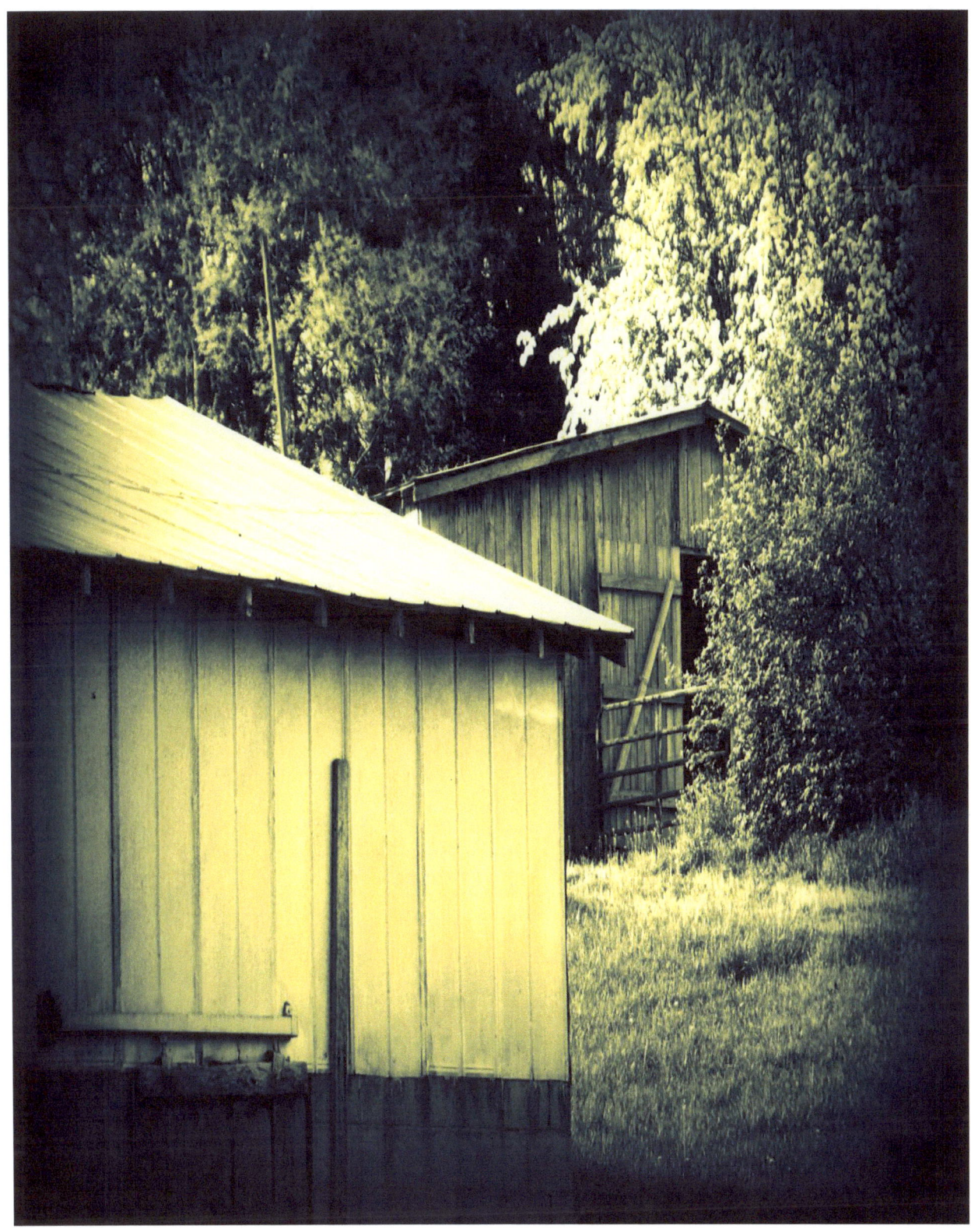

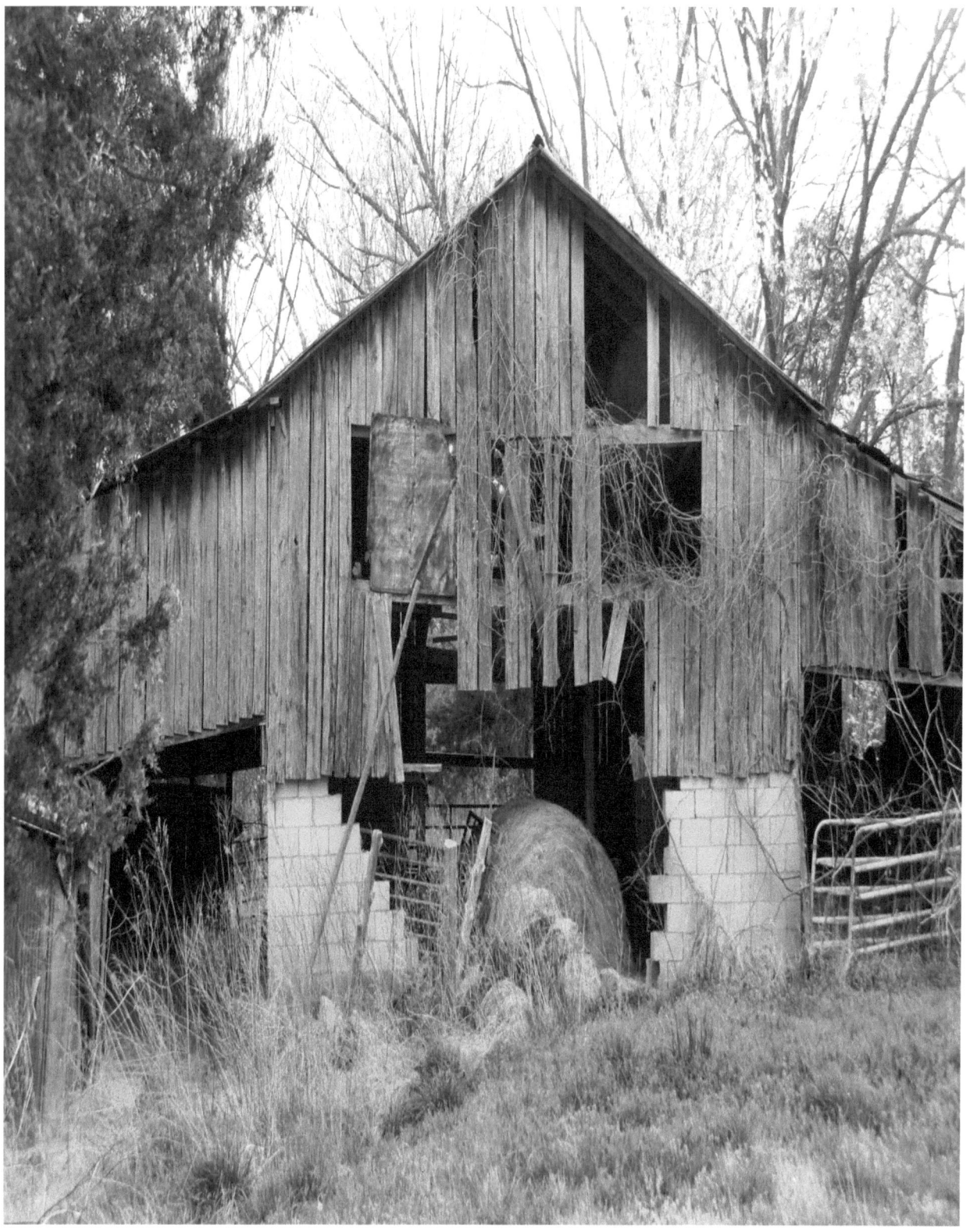

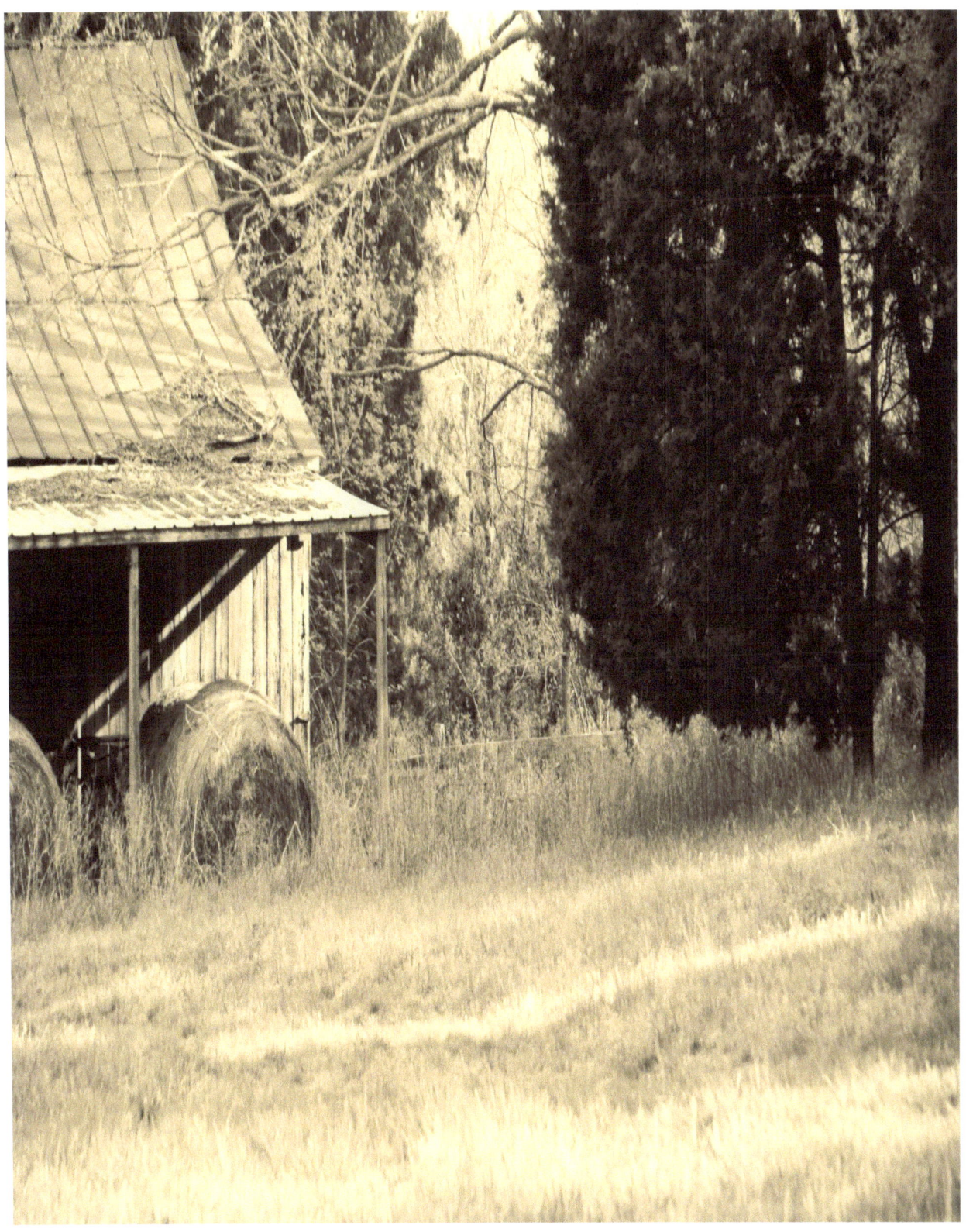

Forests, lakes, and rivers, clouds and winds, stars and flowers,
stupendous glaciers and crystal snowflakes –
every form of animate or inanimate existence,
leaves its impress upon the soul of man.
Orison Swett Marden

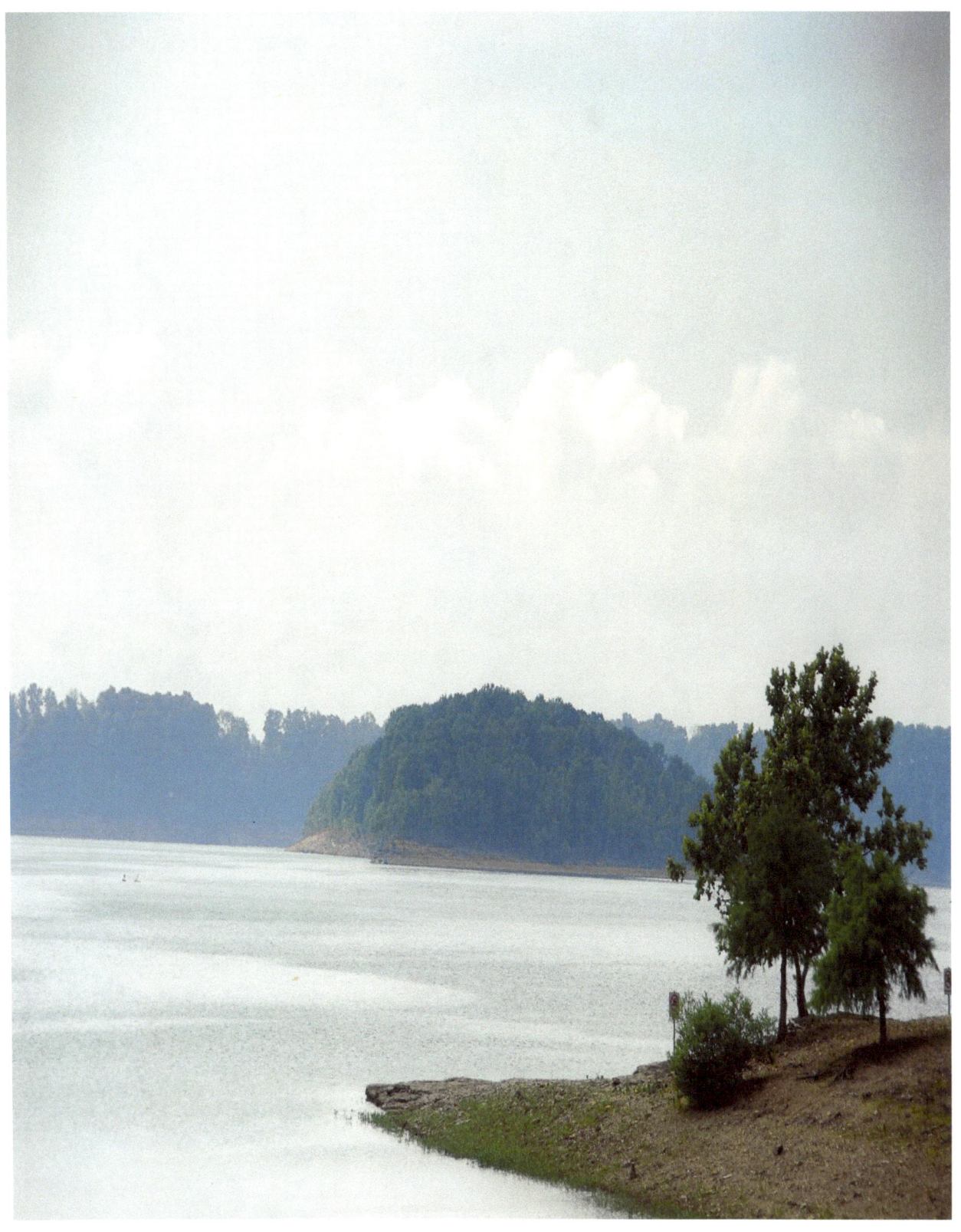

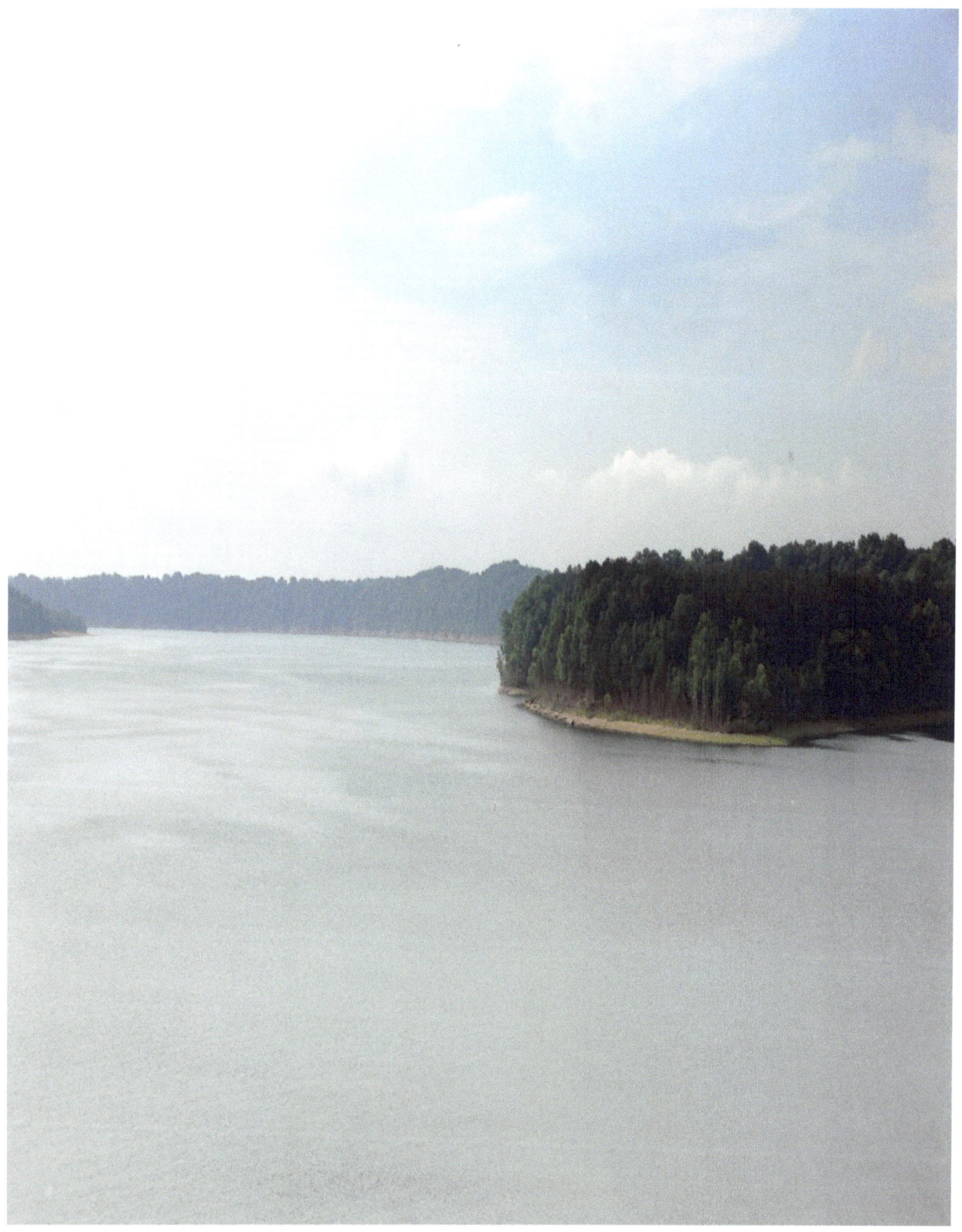

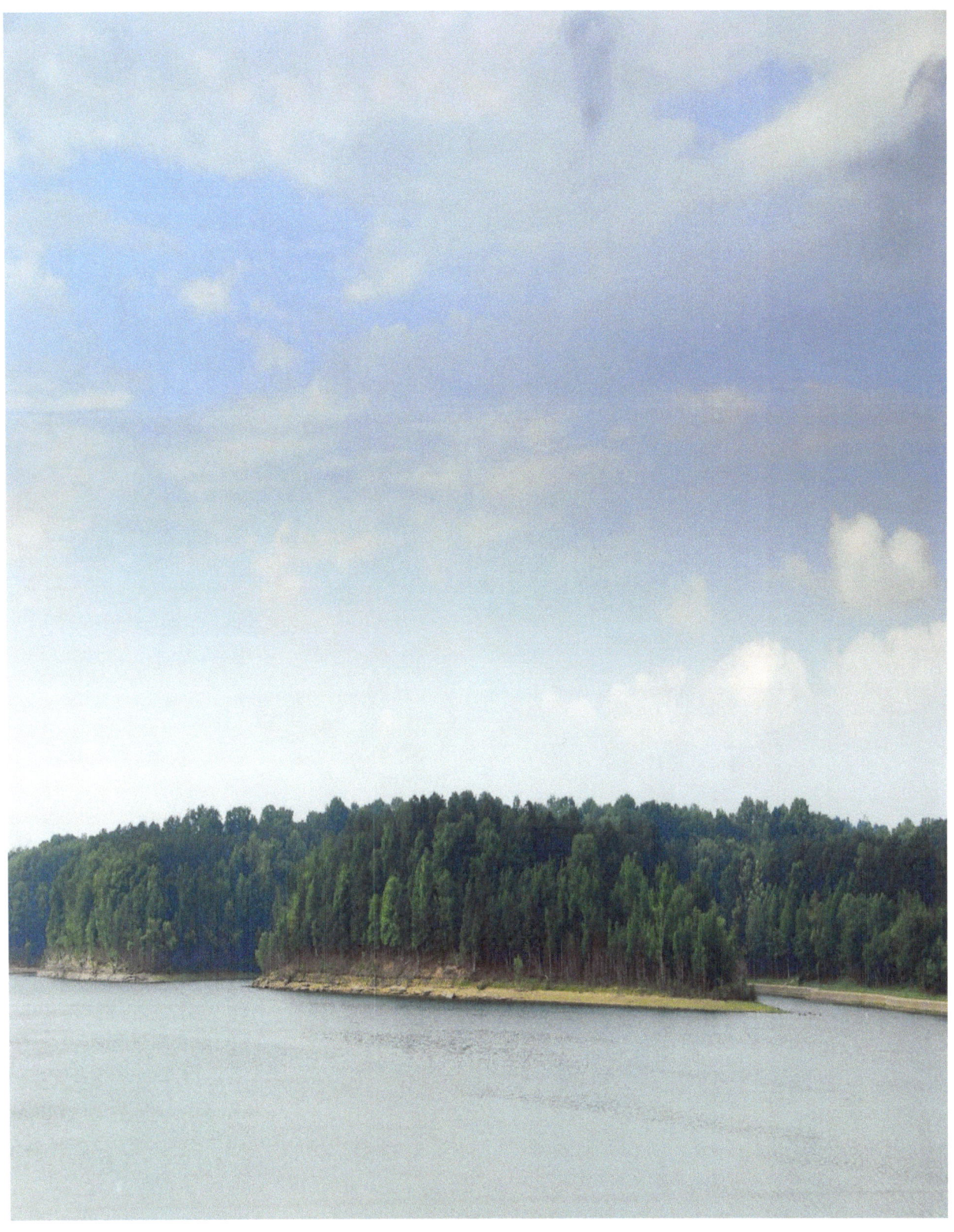

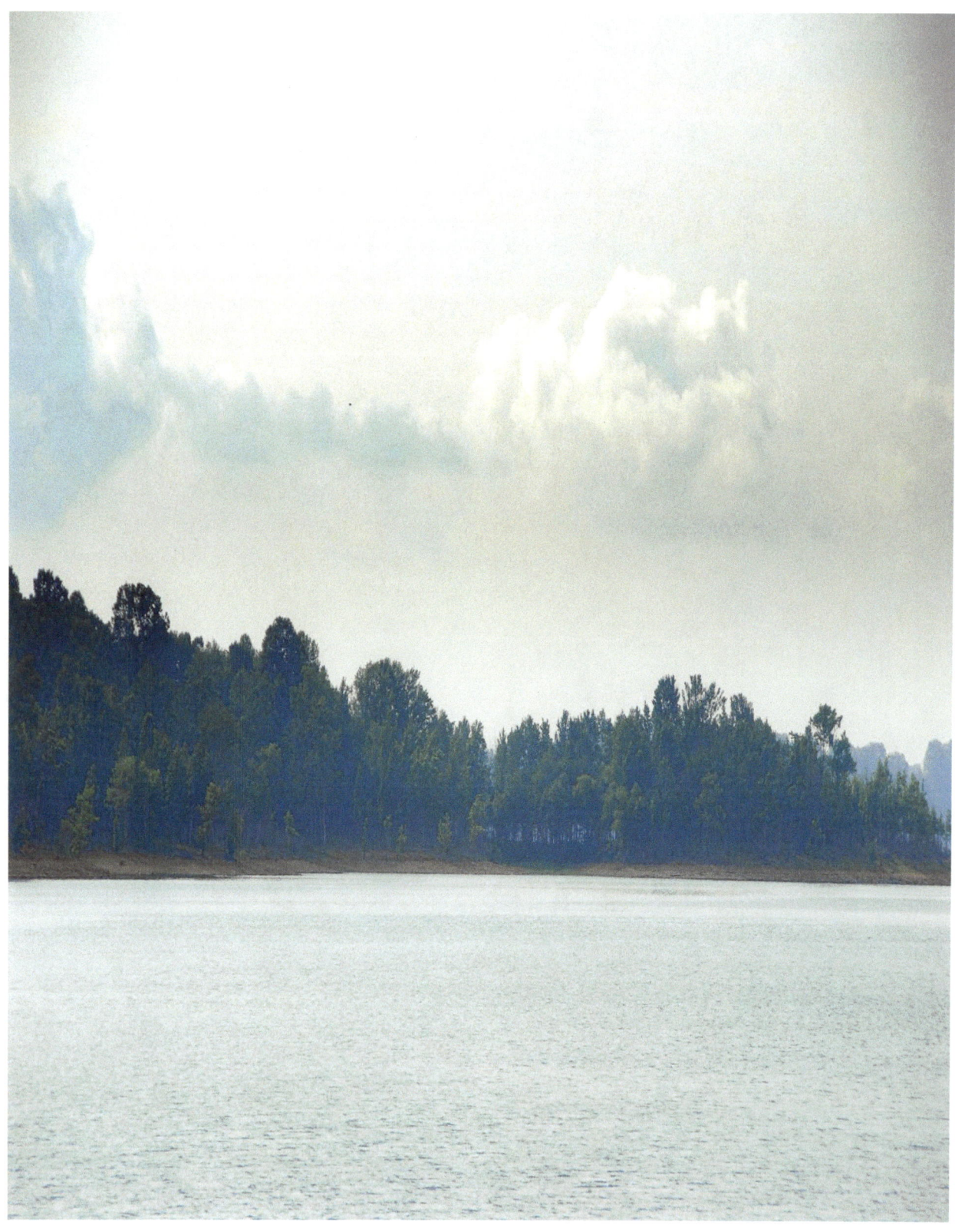

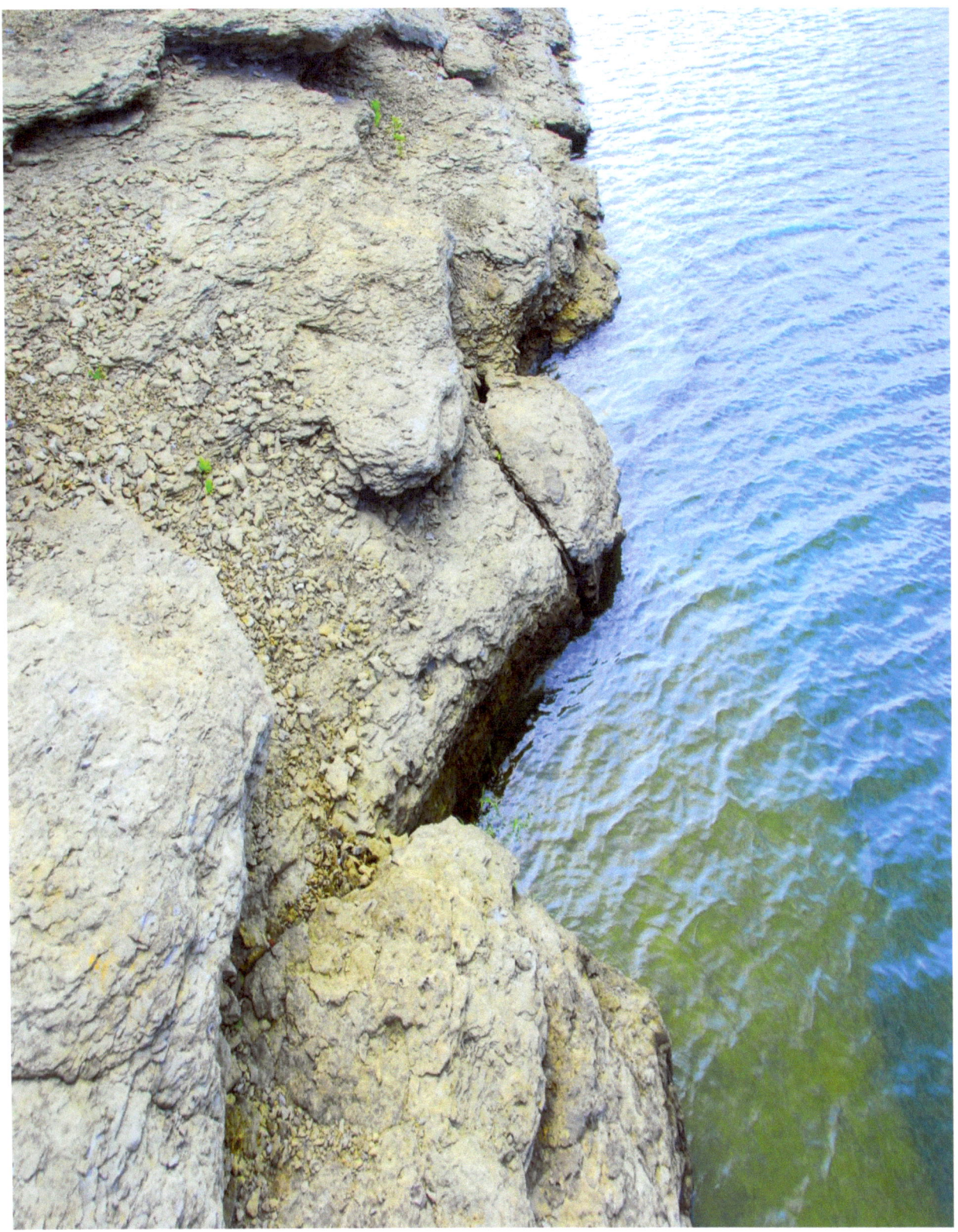

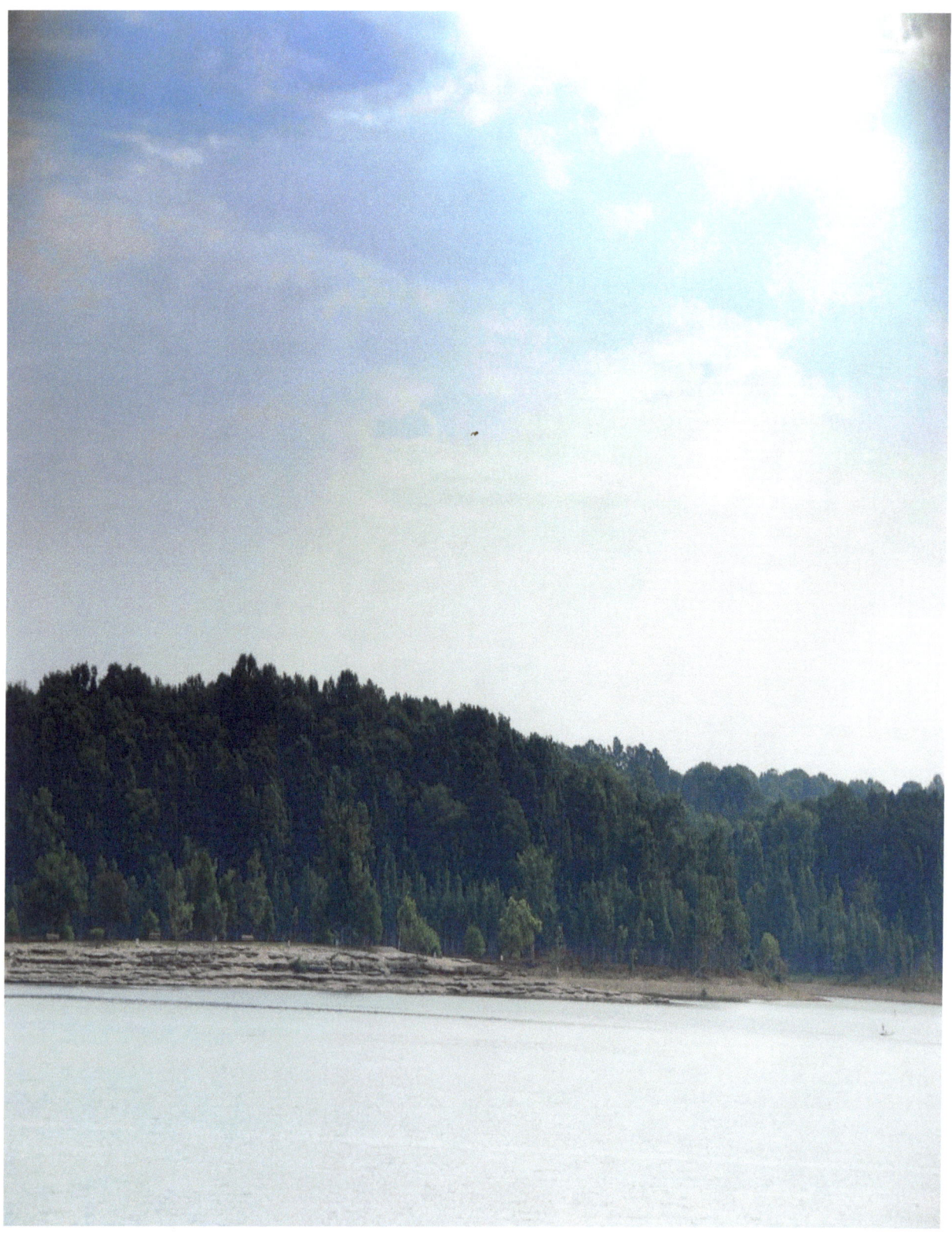

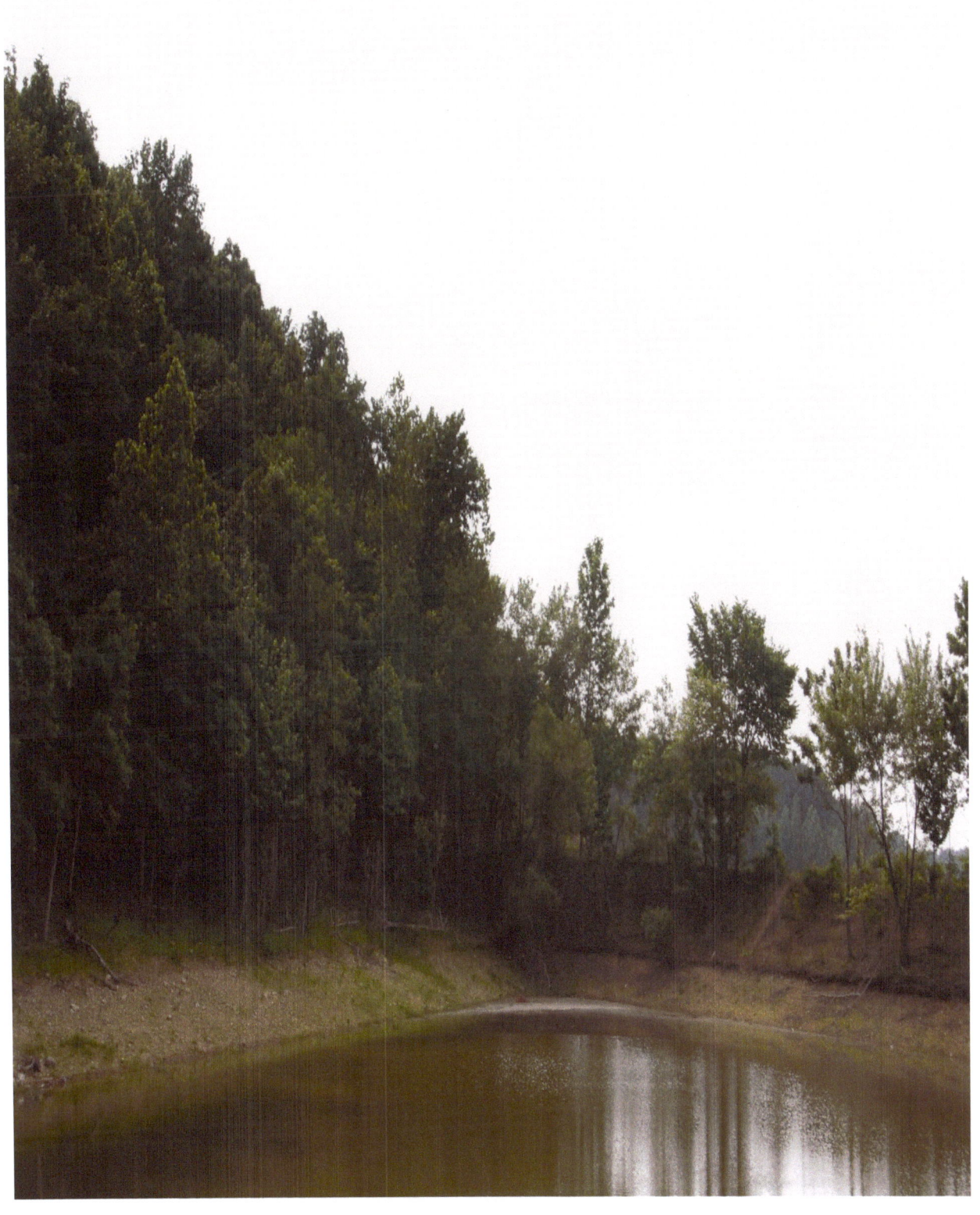

Our works decay and disappear but God gentlest works stay
looking down on the ruins we toil to rear.
Walter Smith

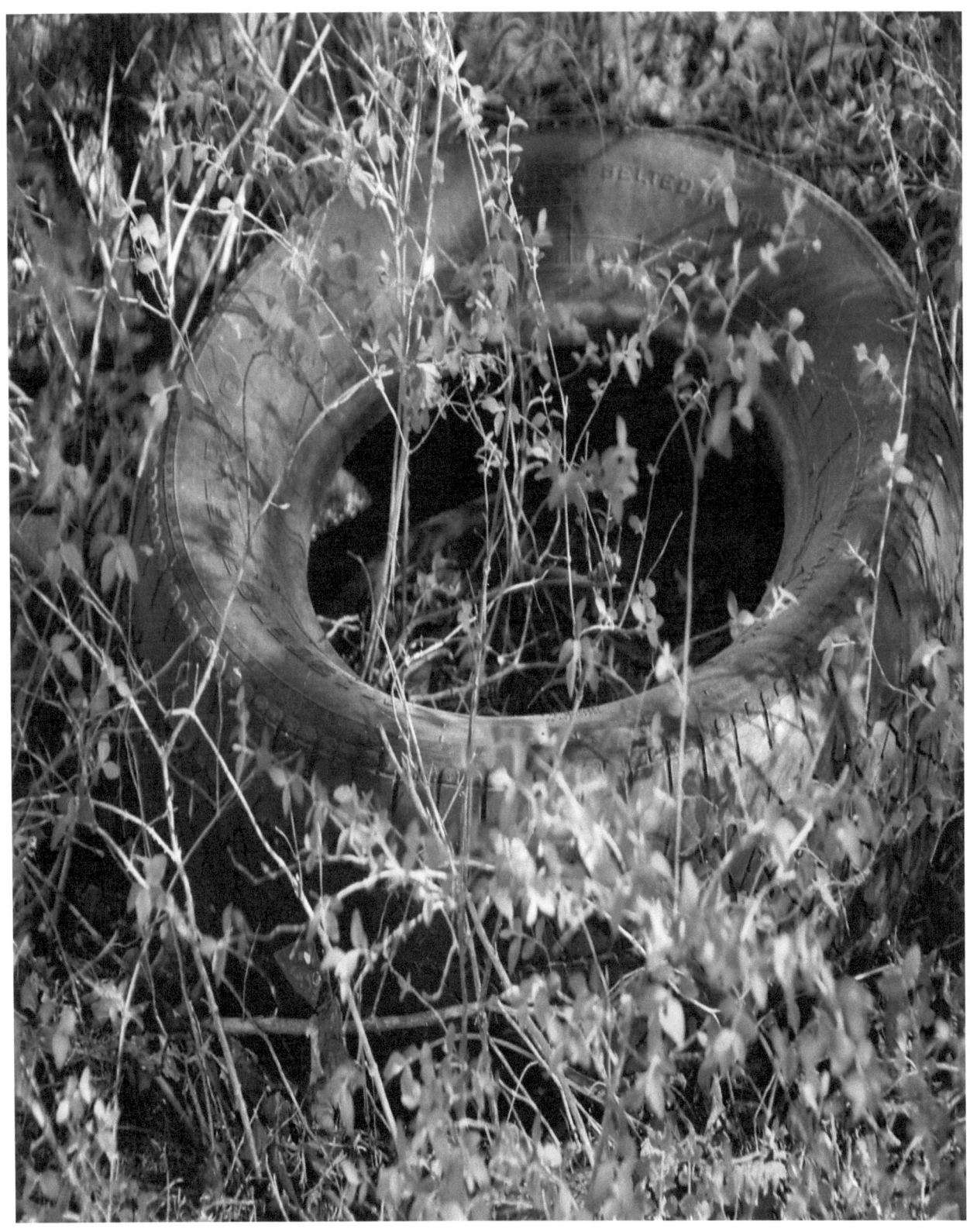

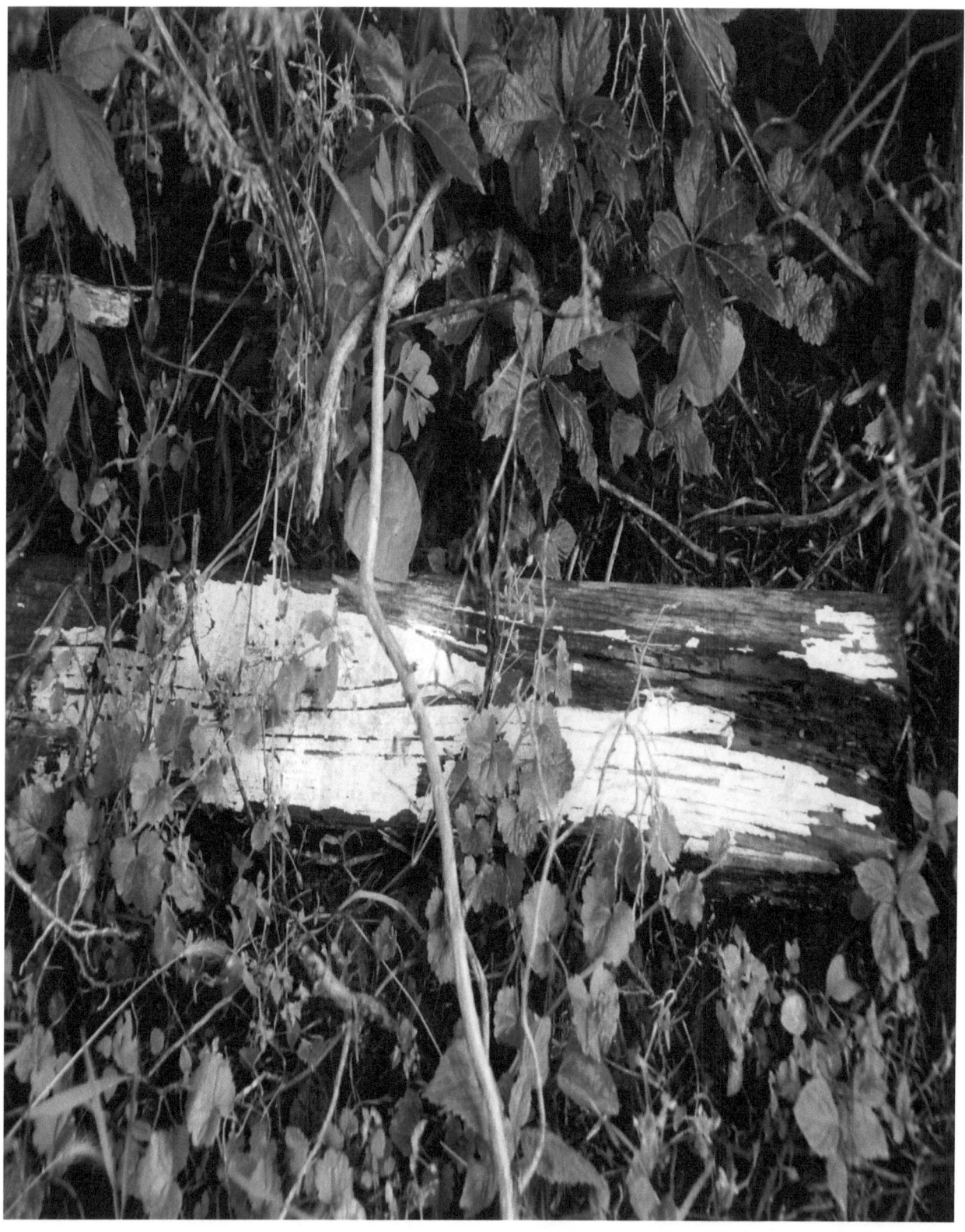

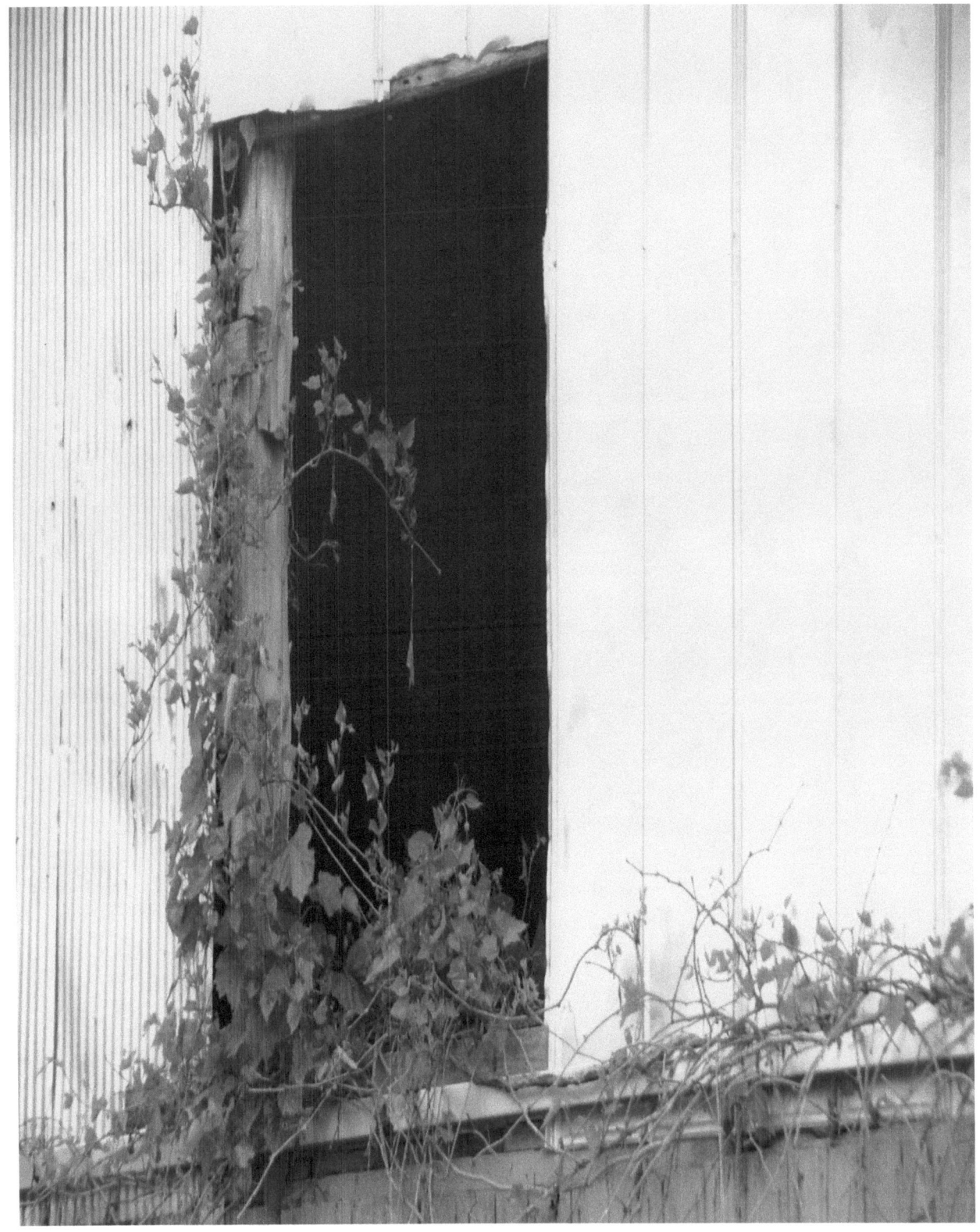

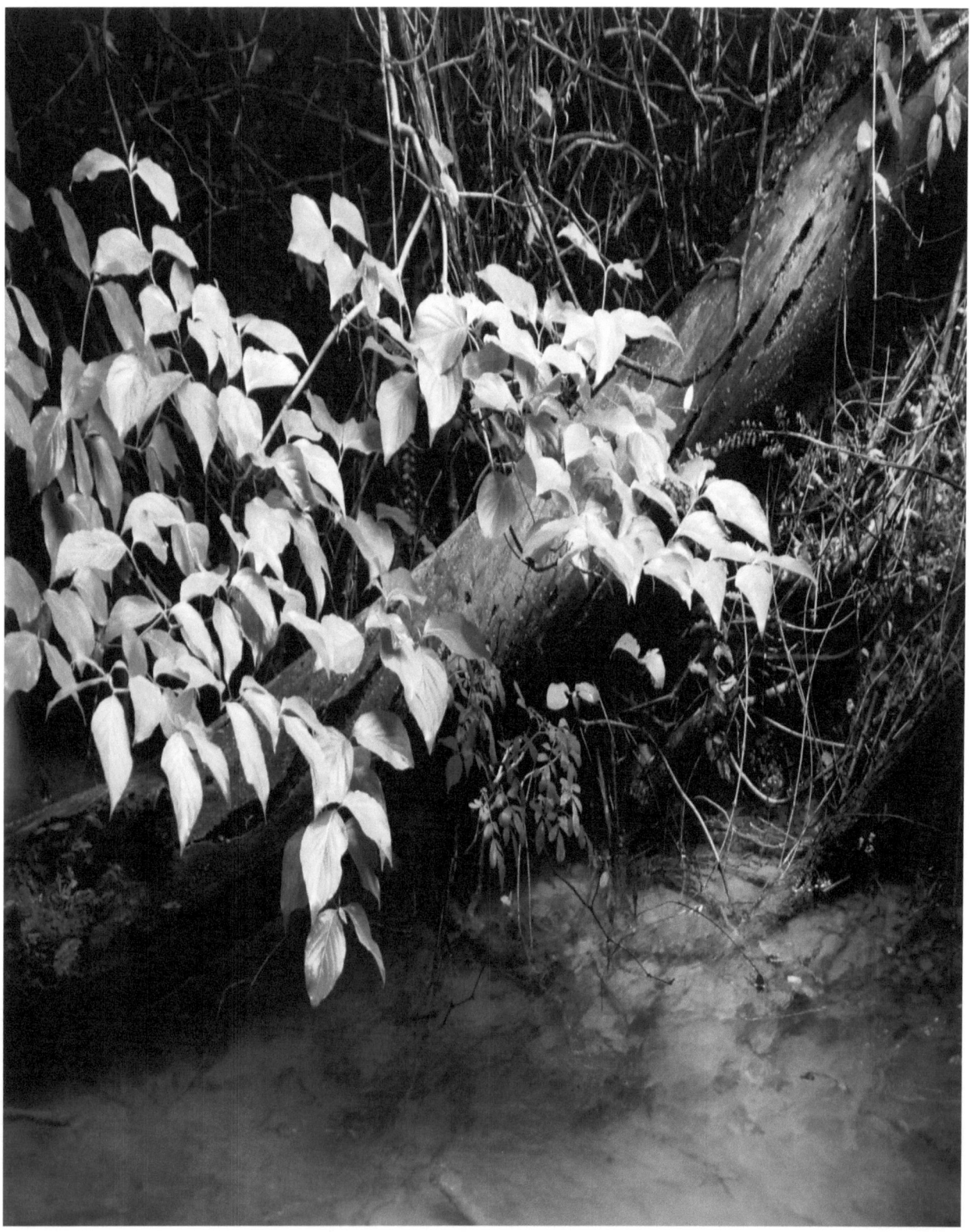

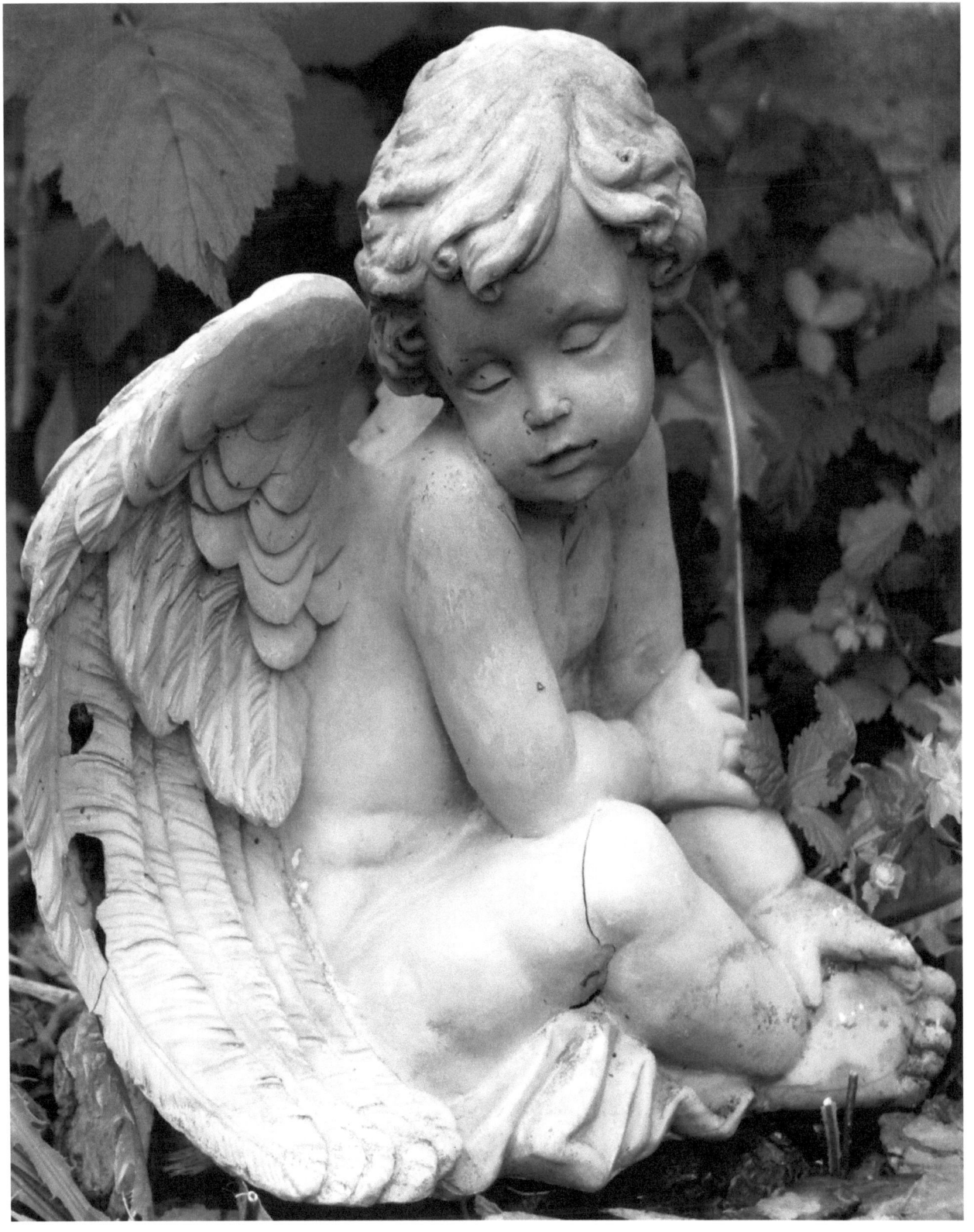

This is what you shall do; Love the earth and sun and the animals, despise riches, give alms to everyone that asks, stand up for the stupid and crazy, devote your income and labor to others, hate tyrants, argue not concerning God, have patience and indulgence toward the people, take off your hat to nothing known or unknown or to any man or number of men, go freely with powerful uneducated persons and with the young and with the mothers of families, read these leaves in the open air every season of every year of your life, re-examine all you have been told at school or church or in any book, dismiss whatever insults your own soul, and your very flesh shall be a great poem and have the richest fluency not only in its words but in the silent lines of its lips and face and between the lashes of your eyes and in every motion and joint of your body.
Walt Whitman

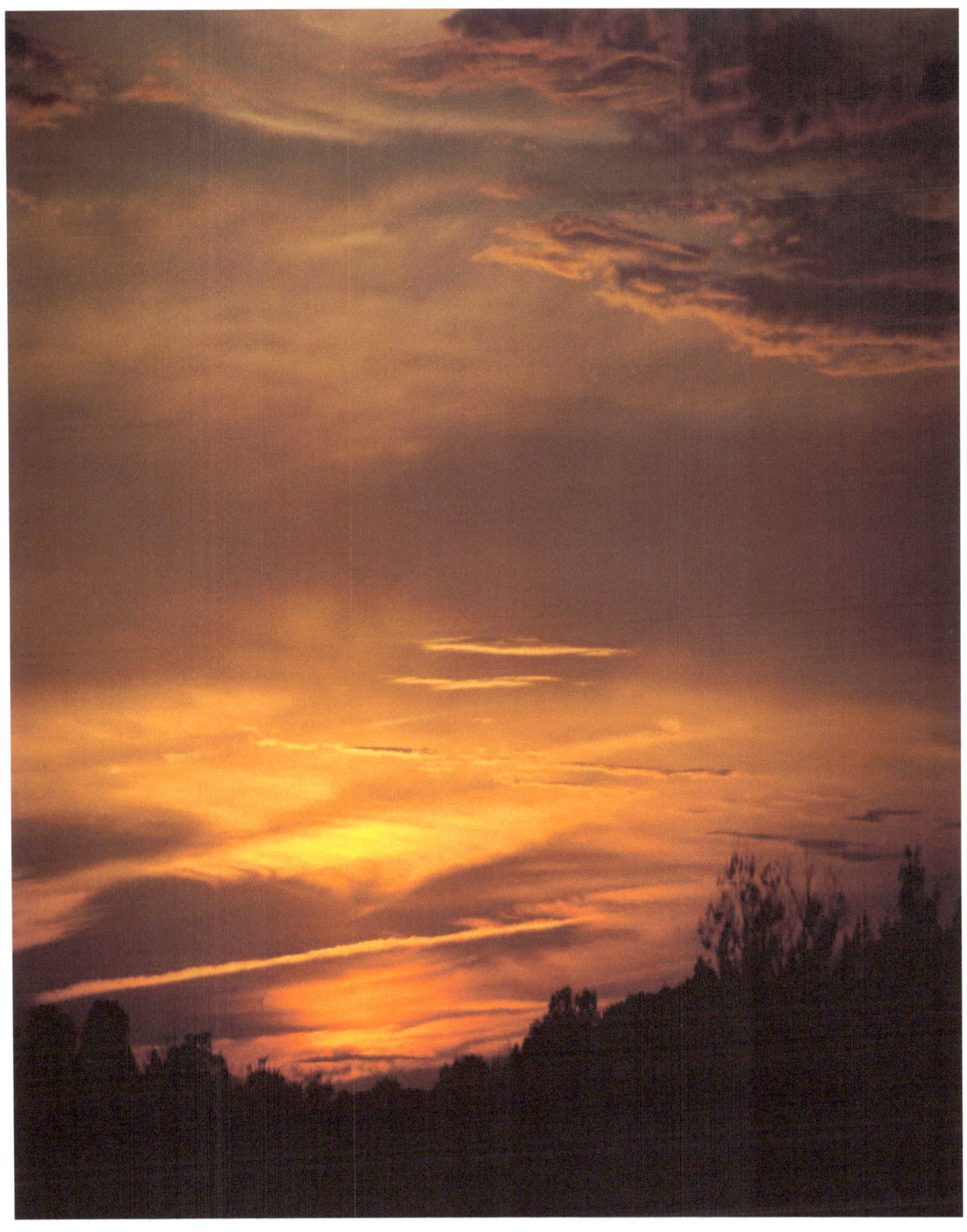

Author's Note

Photography allows one to grasp a fleeting moment of time and hold on to it forever. Taking photographs for me is a somewhat magical experience. Seeing the world through a camera lens allows me to view everything in a different perspective. Even the most insignificant inanimate object can come to life through a photograph when it would have otherwise been overlooked and ignored. I started using a camera at a very young age. I loved to go out and take photographs of things that caught my eye around the farm that I grew up on. I can remember waiting impatiently for my film to be processed and my photos returned so that I would be able to see what images I had captured. Things have evolved significantly since then in the world of photography. No more waiting for a few weeks to receive my photos or holding my breath when I accidently exposed the film.

As I grew older my passion for photography grew stronger than ever. I received many compliments on my work so eventually I started selling my work online. This year I decided I should put a collection together. When I started on this book initially it was going to contain photography concerning one theme. Once I actually started the book though I changed my mind. I just had too much work that I loved to confine it to just one particular genre. I decided to instead make a collection containing a variety of images that I've taken over the years, with the images from the downtown area of Nashville, Tennessee in the first portion of the book and the images taken throughout South Central Kentucky in the remainder of the book. I have included some of my bestsellers, my personal favorites, and some new releases. I have also included some of my favorite quotes every now and then because really nothing goes better with beautiful photography than a thoughtful quote.

Brandy Lindsey

ABOUT THE AUTHOR

Brandy Lindsey is a freelance photographer who works out of the Kentucky and Tennessee areas. She primarily focuses on nature and landscape photography. Antiques are another one of her passions. When not out taking photos she is usually searching estate sales for treasures that she can restore for others to enjoy.

www.ingramcontent.com/pod-product-compliance
Lightning Source LLC
Chambersburg PA
CBHW051055180526
45172CB00002B/647